Cool Type 2wo

CoolType2wo.

SpencerD
rateAndJütkaSalavetzFo
rwardByP.ScottM
akelaA
ndLaurieHaycockMakela
BackwardByJoshuaBe
rger.

NORTH LIGHT BOOKS
CINCINNATI, OHIO
www.nlbooks.com

ACKNOWLEDGMENTS

To Lynn Haller, Linda Hwang, and everybody at North Light Books who believed in this vision. To Ariel and Justin for their guiding spirit. To Chris Ashworth, P. Scott and Laurie Haycock Makela, and Joshua Berger for their invaluable contribution, and all the "cool type" people who contributed to this book. To all the typeheads and typefaces of the world.

Visit our Web site at www.howdesign.com for more resources for graphic designers.

03 02 01 00 99 5 4 3 2 1

Library of Congress Cataloging-in-Publication Data

Drate, Spencer.
 Cool type two/Spencer Drate and Jütka Salavetz.
 p. cm.
 Includes index.
 ISBN 0-89134-932-4 (alk. paper)
 1. Graphic design (Typography) 2. Graphic design (Typography)—United States. I. Salavetz, Jütka. II. Title. III.
Title: Cool type 2
Z246 .D73 1999
686.2'2—dc21 99-32186
 CIP

Edited by Lynn Haller and Linda H. Hwang
Cover design by Chris Ashworth
Interior design by Jütka Salavetz for Justdesign
Forward and Backward designs by Chris Ashworth
Art production by Ruth Preston
Production coordinated by Kristen Heller

The permissions on page 160 constitute an extension of this copyright page.

DEDICATION

This book is dedicated to our parents.

We also dedicate this book to the memory of

P. Scott Makela, who was one of the great designers

of our time and a pleasure to have known.

Contents

Contents, continued

FORWARD

SOUND + TYPOGRAPHY + SCREENS + SPEAKERS
ERECTION AND DELICACY
THE VISUAL ATTACK AND THE AUDIO SÉANCE
THE PRESENT MOMENT THE TRANSMISSION OF PASSION
WHEN VOICE IS NOT A METAPHOR, BUT THE REAL THING
ORIGINALITY BREEDS AGAIN
VOICE HAND TYPE VOICE
HAND TYPE VOICE
HAND TYPE
V O I C E

Think about the brevity of revival cycles, such as bell-bottoms. For the most colorful part of the 1960s and 1970s, bell-bottoms went with tight tops, low-slung belts, and in some circles, a little vest. Everybody knows that. Even our seven-year-old daughter knows that. She wears a pair torn at the knees and heels night and day and was a hippie for Halloween; so were eight other kids at her elementary school. Define "hippie" to a seven-year-old: something about freedom, music

Layout: Chris Ashworth – Still
Image: John Holden

year.)

Our relationship with "themness" began as students of graphic design in the late 1970s. We were told that Univers is the only typeface we would need for a lifetime. Learning about Univers typeface gave a thrill equivalent to wearing a starched white shirt for the first time – not a bad feeling, just a cleaned-up, adult version of ourselves. Univers, like a starched shirt, could imply clarity of mind and eagerness to fit in. This was not really the "express yourself" attitude of a hippie; it represented our transformation into capitalists.

Adrian Frutiger, the designer of Univers, is seventy years old. At a recent Atypl Conference in Lyon, France, he was the hottest, most respected speaker on the three-day program. Even gossipy sightings such as "I saw him come out of the restroom–his fly was down!" were heard, the buzz was so high. For this elite forty-year-old organization, which makes tight distinctions among type designers, typographers, and graphic designers, Frutiger is as big a star as it could ever be hoped. Frutiger emphasized the relationship of drawing to typography, spoke intimately of the hand drawings

which lead to the font, and when asked about the italics in Univers, snapped, "That wasn't my idea." The corporate universality, the perfection-prone, machine aesthetic of Univers wasn't all his idea either. But it is, by the way, making a NeoDevo come-back. Frutiger is

cool.

By **P. Scott + Laurie Haycock Makela**

Philippe Apeloig studied at the École Nationale Supérieure des Arts Appliqués and the École Nationale Supérieure des Arts Décoratifs in Paris. In 1988 he received a grant from the French government to work and study with April Greiman in Los Angeles; later he also received a grant from the French Ministry of Culture to research typography at the French Academy of Art (Villa Medicis) in Rome. He opened his studio, Philippe Apeloig Design, in 1989. Since 1992 he has taught typography at the École Nationale Supérieure des Arts Décoratifs in Paris. He is an art consultant for the Musée du Louvre and has had exhibits in France and Japan.

Philippe Apeloig

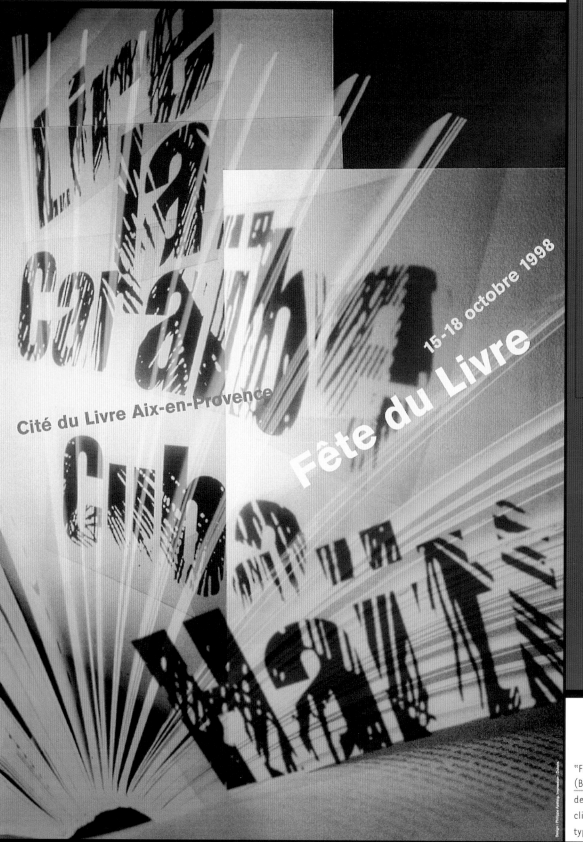

"FÊTE DU LIVRE"
(BETWEEN CUBA AND HAITI)/POSTER
designer/art director: Philippe Apeloig;
client: Cité du Livre, Aix-en-Provence;
typeface: Akzidenz Grotesk

MUSÉE
D'ART
MODERNE
DE LA
VILLE
DE PARIS
20
FÉVRIER-
25
MAI

MUSÉE
DES
MONUMENTS
FRANÇAIS
24
JANVIER-
15
AVRIL

CINÉMA-
THÈQUE
FRANÇAISE
PALAIS
DE CHAILLOT
29
JANVIER-
30
MARS
1997

COLLINE DE CHAILLOT

"LES ANNÉES TRENTE"/POSTER

designer/art director: Philippe Apeloig; typefaces: Bifur, Revisiting Type

This poster is for a series of exhibitions and a film festival about the 1930s.

Fête du Livre

L'Afrique d'l Sud au présent

8-12 octobre 1997 Cité du Livre
Aix-en-Provence

FÊTE DU LIVRE, "L'AFRIQUE DU SUD AU PRÉSENT 1997"/POSTER
designer/art director: Philippe Apeloig; client: Cité du Livre, Aix-en-Provence;
typeface: condensed letters

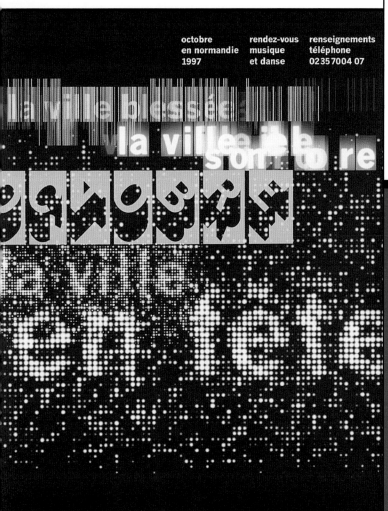

octobre en normandie 1997 | rendez-vous musique et danse | renseignements téléphone 0235700407

FESTIVAL OCTOBRE EN NORMANDIE, "LA VILLE SONORE," 1997/POSTER

designer/art director: Philippe Apeloig; client: Conseil General de la Seine Maritime;
typeface: News Gothic

octobre
fait danser
la saison
octobre

un mois de danse
octobre
en normandie 1996
tél. 36 70 04 07

FESTIVAL OCTOBRE EN NORMANDIE, 1995/
POSTER

designer/art director: Philippe Apeloig; client:
Conseil General de la Seine Maritime;
typeface: Segment

This poster is for Octobre en Normandie, a
music and dance festival; the font was inspired
by Constructivism and the abstraction art
movement.

PHILIPPE APELOIG VOUS SOUHAITE UNE
HEUREUSE ANNÉE 1998/CARD

designer/art director: Philippe Apeloig; client:
self; typeface: custom

This is Apeloig's 1998 New Year's card; he
aimed for an abstract, minimal look. For an
added effect, silver metallic ink was
overprinted on black.

The Attik

MTV ICE/VIDEO

creative directors: Simon Needham (group), James Sommerville (group), Simon Dixon (U.S.), Aporva Baxi (U.K.); client: MTV USA; typefaces: custom

The extreme design approach—cold, sharp and aggressive techniques—complements the abstract sound design to evoke "rock."

James Sommerville and Simon Needham started their graphic design company in Sommerville's grandma's attic bedroom in 1986. Within a few years the client traffic up and down the narrow attic stairway became too much of a bother, and Sommerville and Needham opened their first official Attik office in the town center of Huddersfield, England. Their studio has rapidly expanded from that humble beginning to an international business with branches in London, the U.S., and, in 1999, Australia.

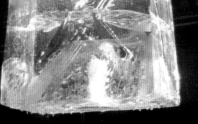

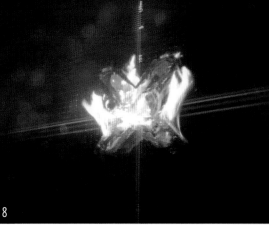

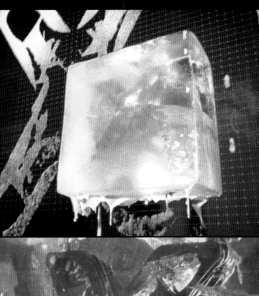

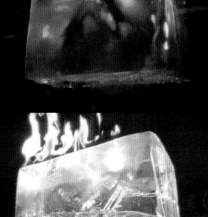

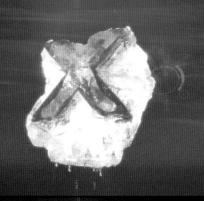

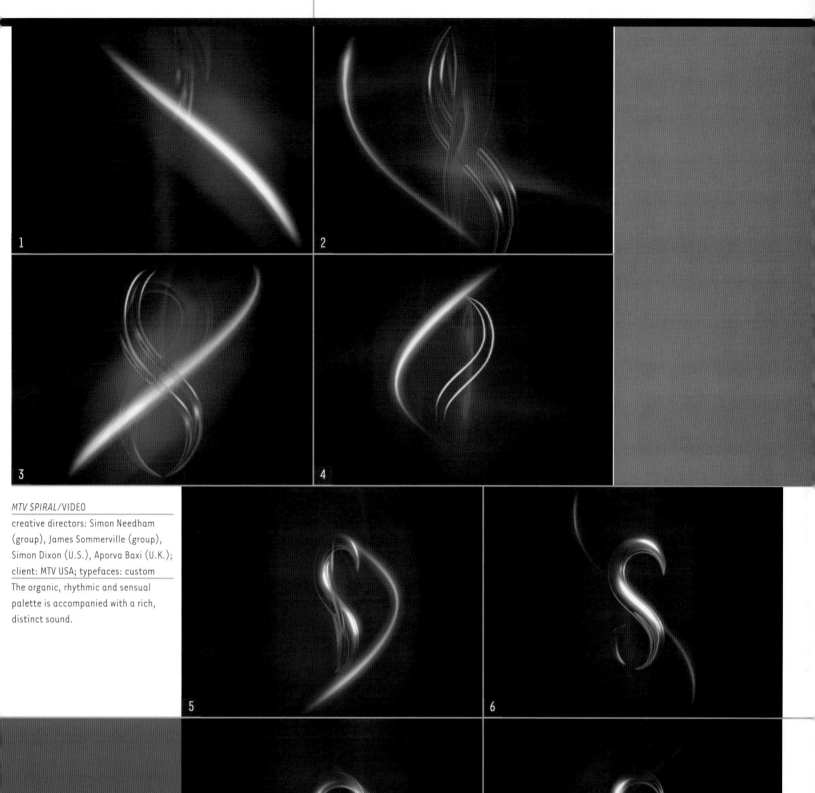

MTV SPIRAL/VIDEO

creative directors: Simon Needham (group), James Sommerville (group), Simon Dixon (U.S.), Aporva Baxi (U.K.); client: MTV USA; typefaces: custom
The organic, rhythmic and sensual palette is accompanied with a rich, distinct sound.

NIKE/POSTERS
creative directors: Simon Needham
(group), James Sommerville
(group), Simon Dixon (U.S.);
designers: Monica Perez, Gary
Jaques, Tina Lauffer; client: Nike;
typefaces: Stotty, Technique
In order to stop the most jaded of
shoppers, a "wall" of 120-layer
Adobe Photoshop documents was
created, bursting with techno-
logical information, quotes and
imagery.

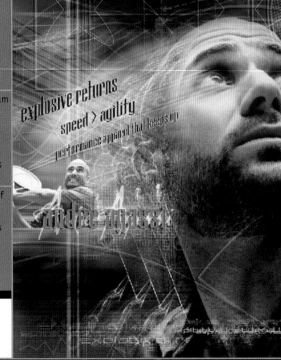

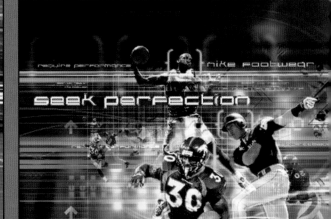

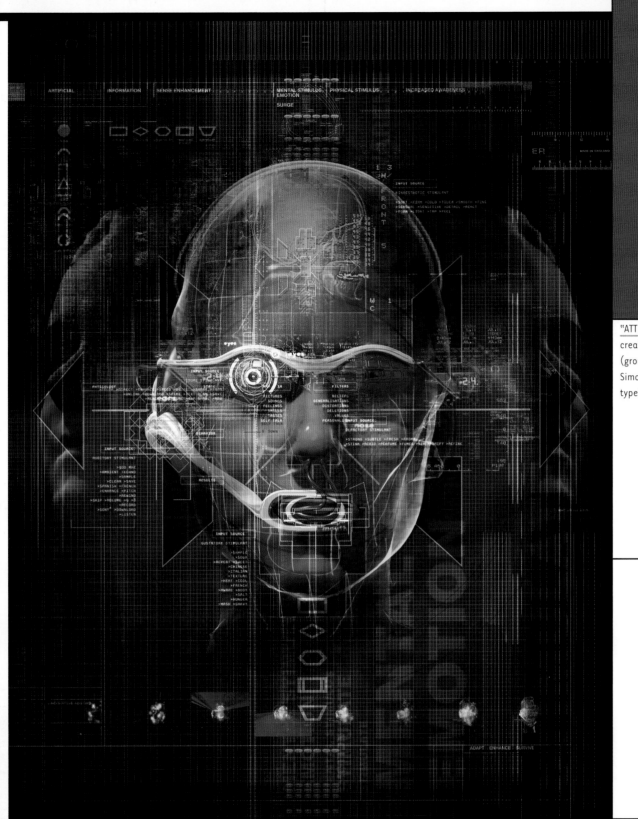

"ATTIK HEAD"/SELF-PROMOTION
creative directors: Simon Needham
(group), James Sommerville (group),
Simon Dixon (U.S.); client: self;
typefaces: various

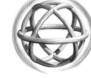 TURNER STUDIOS

TURNER/LOGO
creative directors: Simon Needham (group), James
Sommerville (group), Simon Dixon (U.S.); designer:
Gary Jaques; client: Turner Studios; typeface: custom

Charles Wilkin created Automatic Art and Design in Columbus, Ohio, in 1994 as an outlet for conceptual graphic design, illustration, new media and fine art. Automatic Art and Design has worked with a wide range of clients, including Coca-Cola, Capitol Records, Showtime Networks and Urban Outfitters. As an extension of Automatic Art and Design's experimental process, Wilkin developed Prototype Experimental Foundry as a means to transpose the organic nature of his work into typographic form. In 1996, several of Prototype Experimental Foundry's experimental typefaces were part of "Mixing Messages," an exhibition—held at Cooper-Hewitt, National Design Museum, New York City— that documented innovations in graphic design over the past fifteen years.

Automatic Art and Design

FONT SPECIMEN KIT, "SPACEBOY"/POSTER
designer/art director: Charles Wilkin; design studio: Automatic Art and Design; client: Prototype Experimental Foundry; typeface: Spaceboy
The number 8 was used to generate a more uniform character set; the letterforms share both the upper- and lowercase positions, which replaces the emphasis and visual breaks of traditional uppercase forms.

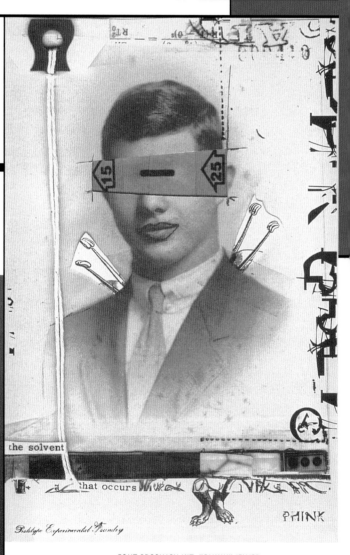

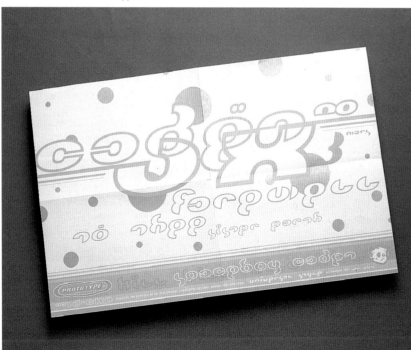

FONT SPECIMEN KIT, "PHINK"/FLYER
designer/art director: Charles Wilkin; design studio: Automatic Art and Design; client: Prototype Experimental Foundry; typeface: Phink

FONT SPECIMEN KIT,
"INTERSTATE 60"/FLYER
designer/art director:
Charles Wilkin; design studio:
Automatic Art and Design;
client: Prototype
Experimental Foundry;
typeface: Interstate 60
The illustration of a dog
jumping through a hoop,
which is on the reverse side
of the font order form,
represents Prototype's
custom font design services.

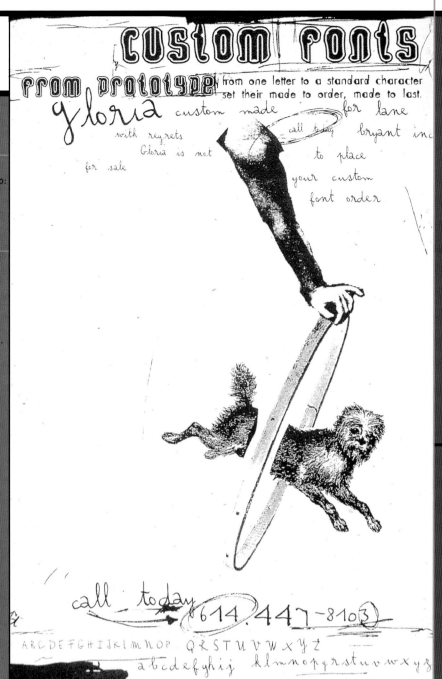

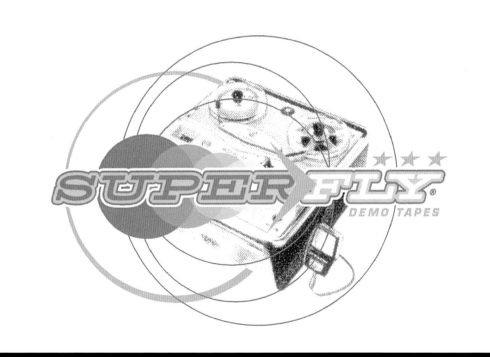

SUPER FLY/T-SHIRT GRAPHIC
designer/art director: Charles
Wilkin; design studio:
Automatic Art and Design;
client: Urban Outfitters; type-
faces: Folio, Hellenic
Wilkin evokes the feelings of
the 1970s without having to
resort to obvious images of
discos, platform shoes and
bell-bottoms.

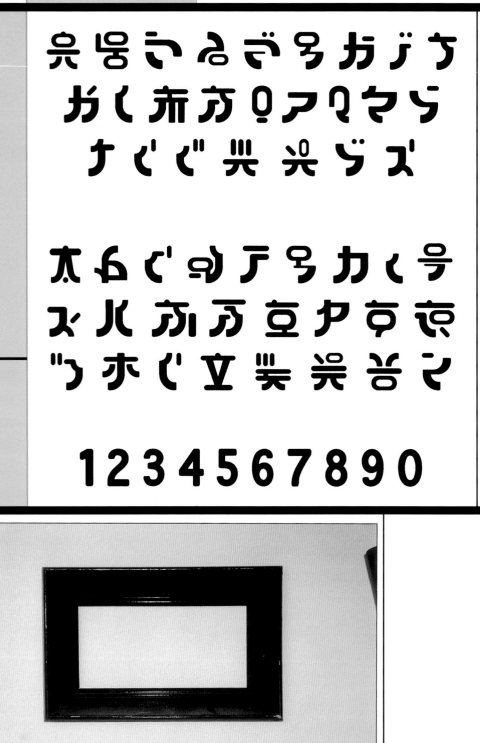

1234567890

CYPHER/FONT

designer/art director: Charles Wilkin; design studio: Automatic Art and Design; client: Prototype Experimental Foundry

This font exhibits the strong influences of Japanese, Chinese and Korean letterforms.

"AUTOMATIC I AM"/ALTERNATE AD

designer/art director: Charles Wilkin; design studio: Automatic Art and Design; client: Automatic Art and Design; photographer: Charles Wilkin; typefaces: Folio, Pure, Cypher

An empty frame, crude typography and digital imagery with the imposing question "Automatic I am. Who and what are you?" are an organic mix of art and human nature, which is the essence of Automatic Art and Design.

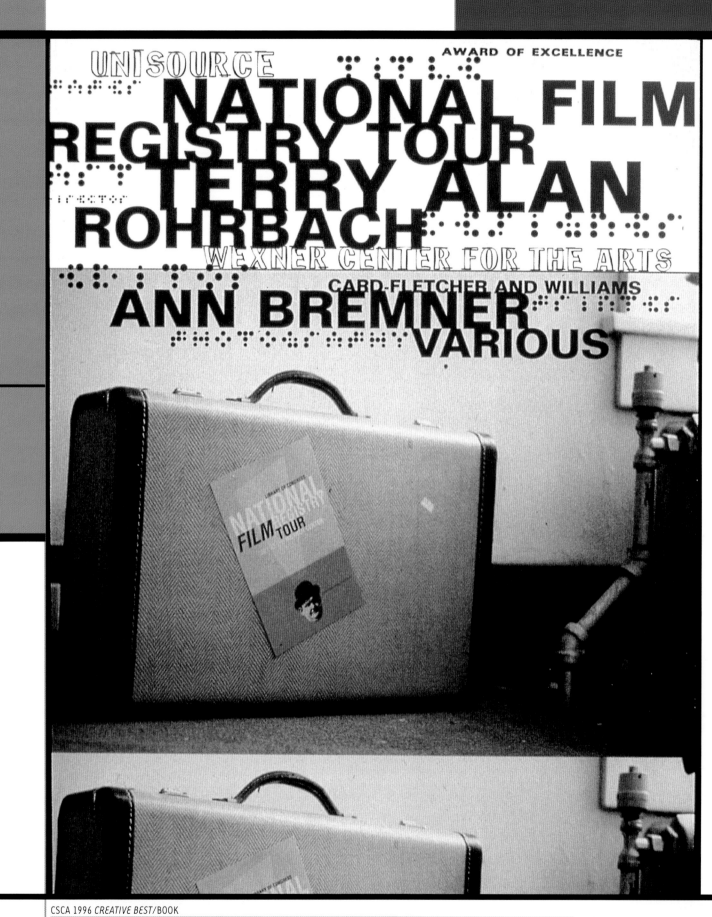

AWARD OF EXCELLENCE

UNISOURCE
NATIONAL FILM
REGISTRY TOUR TERRY ALAN
ROHRBACH
WEXNER CENTER FOR THE ARTS
CARD-FLETCHER AND WILLIAMS
ANN BREMNER
VARIOUS

CSCA 1996 *CREATIVE BEST*/BOOK

designer/art director: Charles Wilkin; design studio: Automatic Art and Design; client: Columbus Society of Communication Arts;
photographers: Chas Krider, Tracey Jolley; illustrator: Charles Wilkin; typefaces: Folio, Frankie, Trixie

This book was a departure from traditional awards books; it used the winning work to create the book, which was achieved by reassembling it into collages and using the work as a graphic. By taking the work out of context, the book becomes a represen-tation of the competition while allowing it to take on its own separate identity.

THE ELLA FITZGERALD
AND DUKE ELLINGTON
*CÔTE D'AZUR
CONCERTS ON
VERVE*/CD COLLECTION
designer/art director:
Chika Azuma; client:
Verve Records; illus-
trator: Luba Lukova;
calligraphy: Marlon
Palleja; typefaces:
Gill Sans (cover),
calligraphy, Gill Sans
(interior)
Based on samples
written by French
calligraphers, the
calligraphy gives the
package a "European"
feel.

Chika Azuma started out as a magazine editor in Osaka, Japan, before relocating to New York to study design at the School of Visual Arts. She has been with Verve Records since 1996. Her work was included in the photography book *Inside and Out*—a collection of photos by students in the education program run by the International Center of Photography. She received a Grammy award for best packaging in 1997, which made her parents very happy, although to this day they tell their friends that she has won an Oscar.

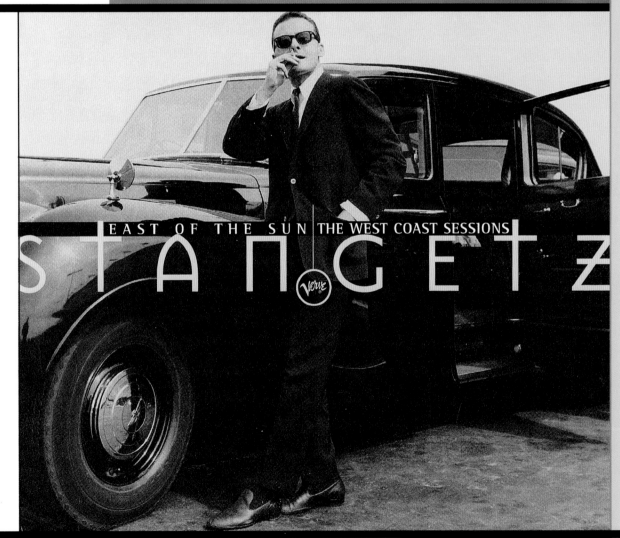

STAN GETZ, EAST OF THE SUN: THE WEST COAST SESSIONS/CD COVER
designer/art director: Chika Azuma; client: Verve Records; photographers: Lou Levy (cover);
Phil Stern, Carole Reiff, Paul J. Hoeffler (interior); typefaces: Mason Sans, Rotis Serif (cover);
Trade Gothic (interior)
Azuma credits the car as the inspiration for the type: "simple, cool and aloof."

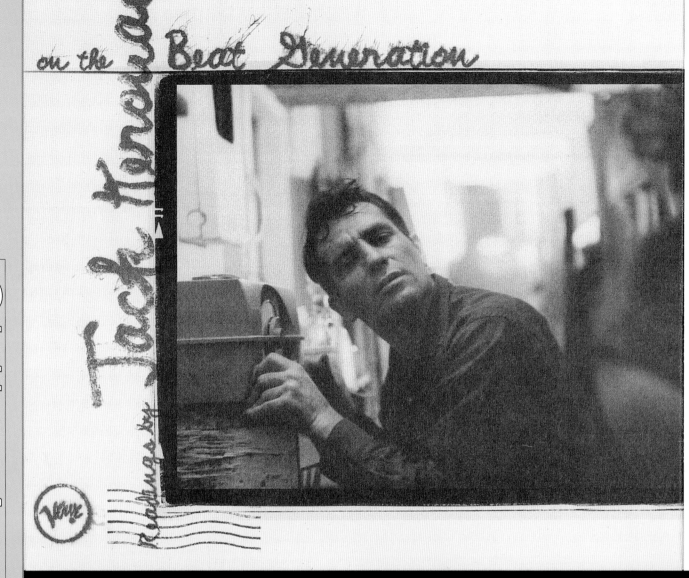

on the *Beat Generation*

Jack Kerouac

Readings by

Chika Azuma

READINGS BY JACK KEROUAC ON THE BEAT GENERATION/CD COVER

designer/art director: Chika Azuma; client: Verve Records;
photographers: John Cohen (cover); Allen Ginsberg, Burt
Goldblatt, R. Deo (interior); typefaces: custom

The type was posthumously traced from Allen Ginsberg's hand-
writing, which was a natural choice since he wrote the essay.

J.J. JOHNSON, *THE BRASS ORCHESTRA*/CD PACKAGE

designer/art director: Chika Azuma; client: Verve Records; photographer: Chika
Azuma (cover); typefaces: Letter Gothic, Matrix Script Bold, Trade Gothic No. 20
Bold Condensed (cover)

For this package Azuma used functional type mixed with decorative type.

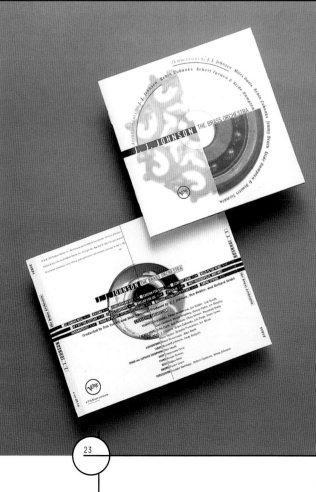

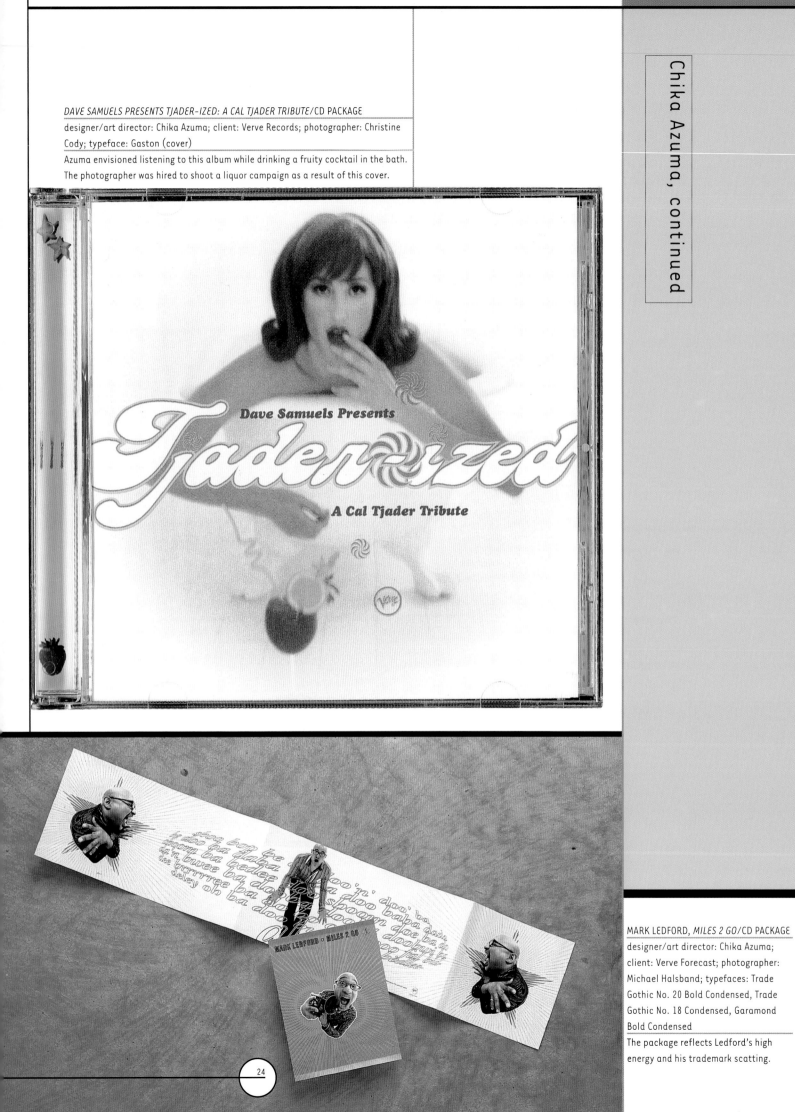

DAVE SAMUELS PRESENTS TJADER-IZED: A CAL TJADER TRIBUTE/CD PACKAGE
designer/art director: Chika Azuma; client: Verve Records; photographer: Christine Cody; typeface: Gaston (cover)
Azuma envisioned listening to this album while drinking a fruity cocktail in the bath. The photographer was hired to shoot a liquor campaign as a result of this cover.

MARK LEDFORD, *MILES 2 GO*/CD PACKAGE
designer/art director: Chika Azuma; client: Verve Forecast; photographer: Michael Halsband; typefaces: Trade Gothic No. 20 Bold Condensed, Trade Gothic No. 18 Condensed, Garamond Bold Condensed
The package reflects Ledford's high energy and his trademark scatting.

ROLAND KIRK, *TALKIN' VERVE/*
CD PACKAGE
designer/art director: Chika Azuma;
client: Verve Records; photographer:
Chuck Stewart; typefaces: Trade
Gothic, Matrix Script (front cover);
Rotis Semi Sans (back cover)
How do you add movement and
funkiness to static visuals? Azuma
dissected and repeated the images
using silkscreen, adding color and
rawness to the period piece.

Bau-Da Design Lab, Inc.

As its principals describe it, Bau-Da Design Lab is "an organization of structured coily bedsprings inside a...king-size mattress, upon which a hyperactive, curly-haired kid chaotically bounces up and down." Their main reason for getting out of bed in the morning is to implement and sustain the glorious harmony found between the opposing ideals of complete form (mattress) and pure, uninhibited action (kid). "Bau-Da" is the art of finding the balance between the adult and the inner child.

the long hard road out of hell
MARILYN MANSON
WITH NEIL STRAUSS

MARILYN MANSON, *THE LONG HARD ROAD OUT OF HELL*/BOOK JACKET
designer/art director: Paul Brown; design studio: Bau-Da Design Lab, Inc.; client: Regan Books; photographer: Joseph Cultice; typefaces: New Baskerville, Commercial Script

MARILYN MANSON, *ANTICHRIST SUPERSTAR*/CD COVER
designer/art director: Paul Brown; design studio: Bau-Da Design Lab, Inc.; client: Nothing/Interscope Records; photographer: Dean Karr; typefaces: New Baskerville, Commercial Script

26

KNOWTRIBE, *DIRECTED MOTION*/POSTCARD
designer/art director: Paul Brown; design studio: Bau-Da Design Lab, Inc.; client: Knowtribe; photographer: Robert Fenz; typeface: Myriad

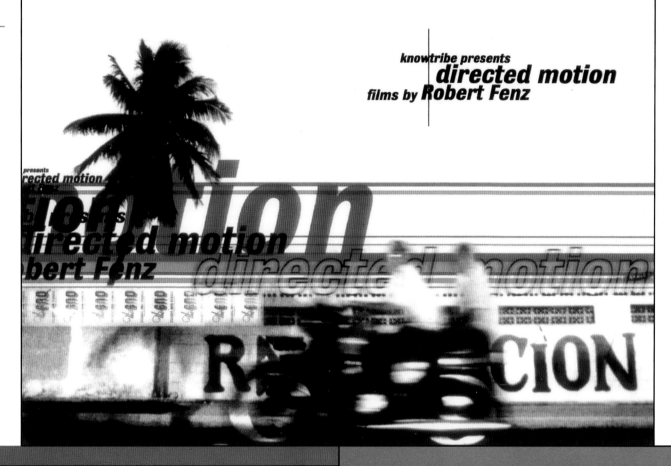

knowtribe presents
directed motion
films by **Robert Fenz**

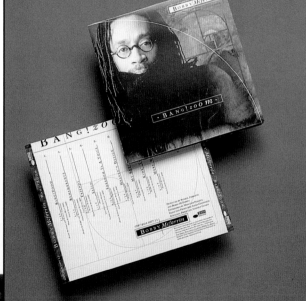

Jim Sleeper
Liberal Racism
Racism

How fixating on race subverts the American dream

BOBBY MCFERRIN, *BANG!ZOOM*/CD PACKAGE
designer/art director: Paul Brown; design studio: Bau-Da Design Lab, Inc.; client: Blue Note; photographer: Mark Seliger; typeface: Garamond

JIM SLEEPER, *LIBERAL RACISM*/BOOK COVER
designer/art director: Paul Brown; design studio: Bau-Da Design Lab, Inc.; client: Penguin Books; typeface: Myriad

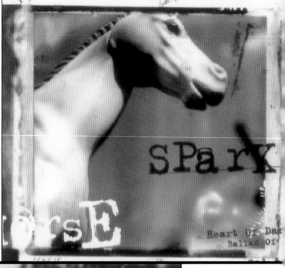

SPARKLEHORSE, *v.d.s.t.p.*/CD INSERT
designer/art director: Paul Brown; design
studio: Bau-Da Design Lab, Inc.; client:
Capitol Records; photographer: Mark
Linkus; typeface: Trixie

TALK TO ME/BOOK COVER
designer/art director: Paul
Brown; design studio: Bau-Da
Design Lab, Inc.; typefaces: New
Baskerville, Garamond

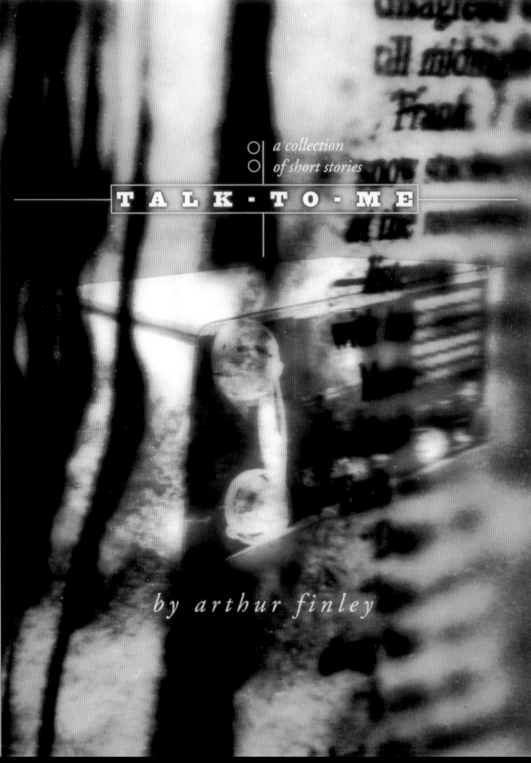

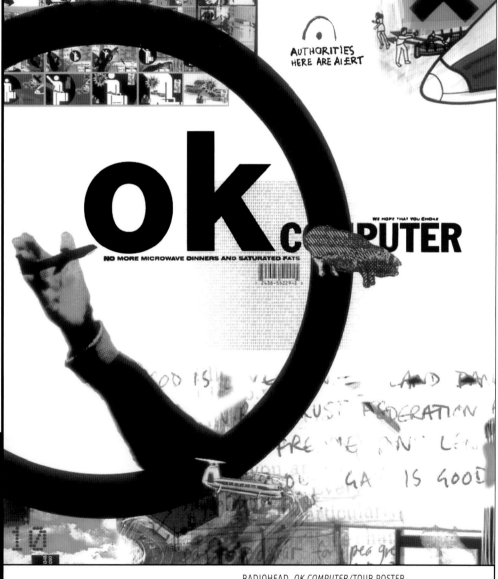

FOO FIGHTERS,
THE COLOUR & THE SHAPE/CD COVER
designer/art director: Paul Brown;
design studio: Bau-Da Design Lab,
Inc.; client: Capitol Records; type-
face: Trade Gothic No. 20 Bold
Condensed

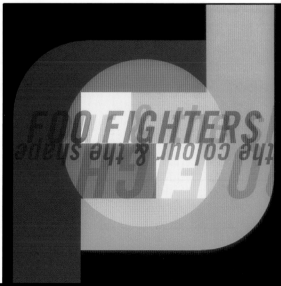

RADIOHEAD, *OK COMPUTER*/TOUR POSTER
designer/art director: Paul Brown; design studio: Bau-Da
Design Lab, Inc.; client: Capitol Records; typeface: Eurostile

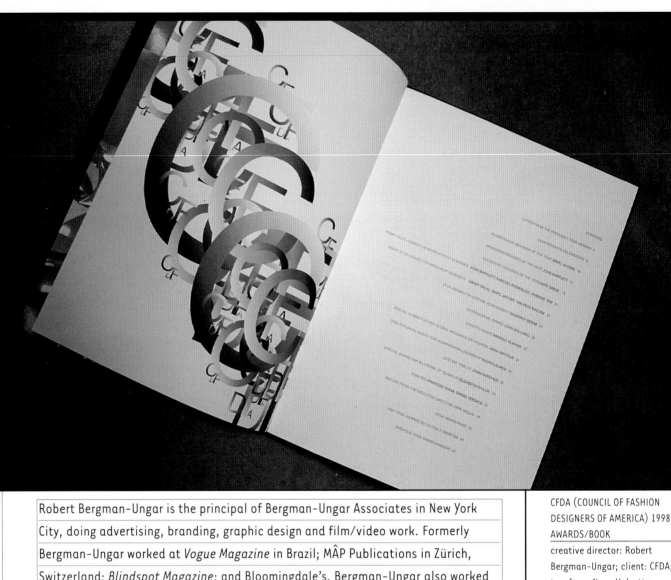

Robert Bergman-Ungar is the principal of Bergman-Ungar Associates in New York City, doing advertising, branding, graphic design and film/video work. Formerly Bergman-Ungar worked at *Vogue Magazine* in Brazil; MÂP Publications in Zürich, Switzerland; *Blindspot Magazine*; and Bloomingdale's. Bergman-Ungar also worked in the feature film industry and as a photojournalist for publications including *Condé Nast Traveler* in South America, North Africa, the Middle East, Europe and the Far East. He worked with Fabien Baron, an art director at *Interview Magazine*, and also for the *Scandinavia Today* program, which is responsible for the development of Scandinavian cultural interests in the U.S.

CFDA (COUNCIL OF FASHION DESIGNERS OF AMERICA) 1998 AWARDS/BOOK
creative director: Robert Bergman-Ungar; client: CFDA; typeface: Neue Helvetica family

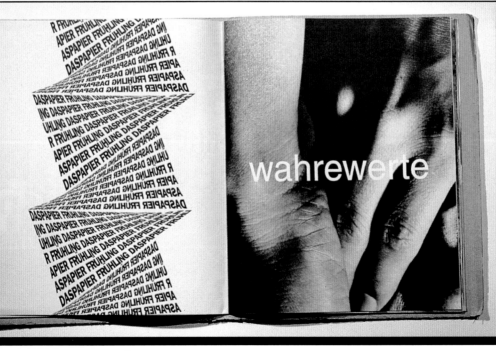

DAS PAPIER (ZÜRICH)/MAGAZINE
creative director: Robert Bergman-Ungar; client: *Das Papier Magazine*; photographer: Albert Watson; typeface: Bodoni Regular
For this spread from the Swiss magazine *Das Papier*, Bergman-Ungar built "sculptures" out of type based on the work of Constantin Brancusi.

MÂP NO. 8/MAGAZINE SPREAD
creative director: Robert Bergman-Ungar; client: MÂP Publications; photographer: Seiju Toda; typeface: Neue Helvetica
This spread consists of an image by a Japanese X-ray technician-turned-photographer and a quote from the Japanese pop writer Masa Sugatsuke.

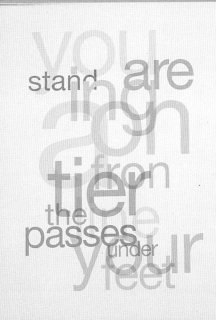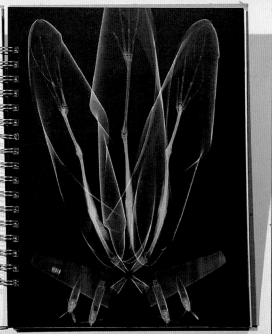

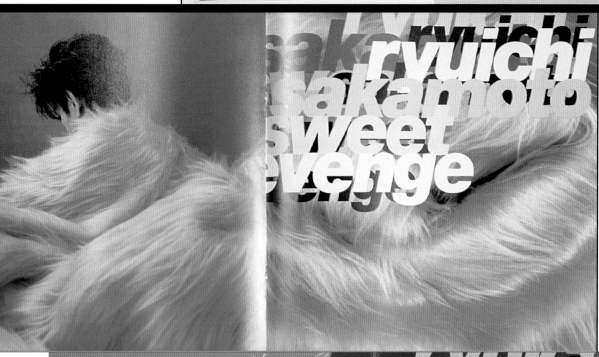

RYUICHI SAKAMOTO,
SWEET REVENGE/CD
PACKAGING
creative director:
Robert Bergman-Ungar;
client: Elektra Records;
photographer: Jean
Baptiste Mondino;
typeface: Neue
Helvetica

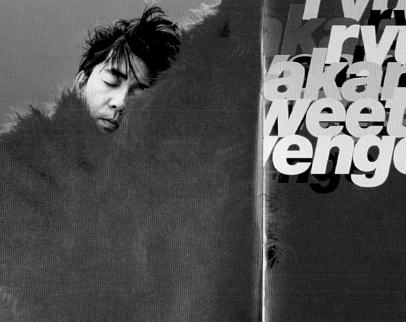

SAKAMOTO/AD

creative director: Robert Bergman-Ungar; client: Warner Bros. Records; photographer: Nick Knight; typeface: Neue Helvetica

This is the Japanese version of the package; the American version had to be made "more readable" but also ended up being more minimal and therefore less strong.

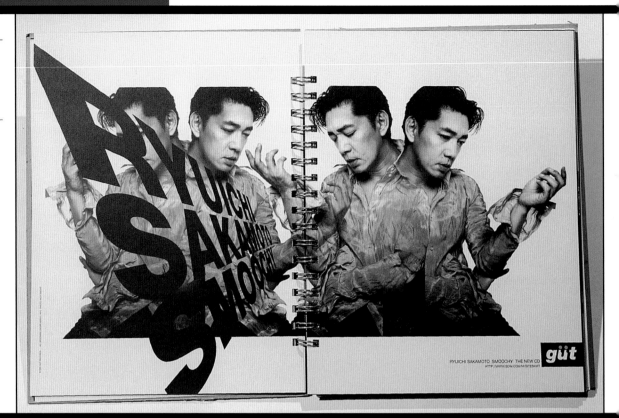

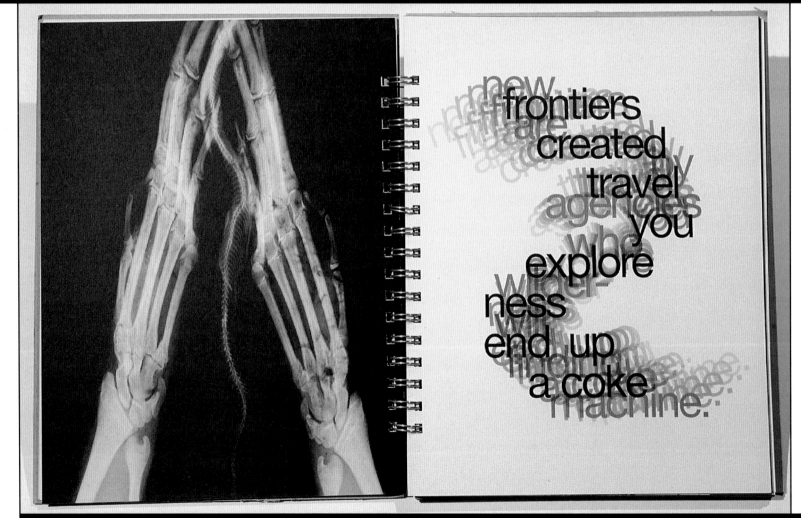

MÂP NO. 8/MAGAZINE SPREAD

creative director: Robert Bergman-Ungar; client: MÂP Publications; photographer: Seiju Toda; typeface: Neue Helvetica

This spread consists of an image by a Japanese X-ray technician-turned-photographer and a quote from the Japanese pop writer Masa Sugatsuke.

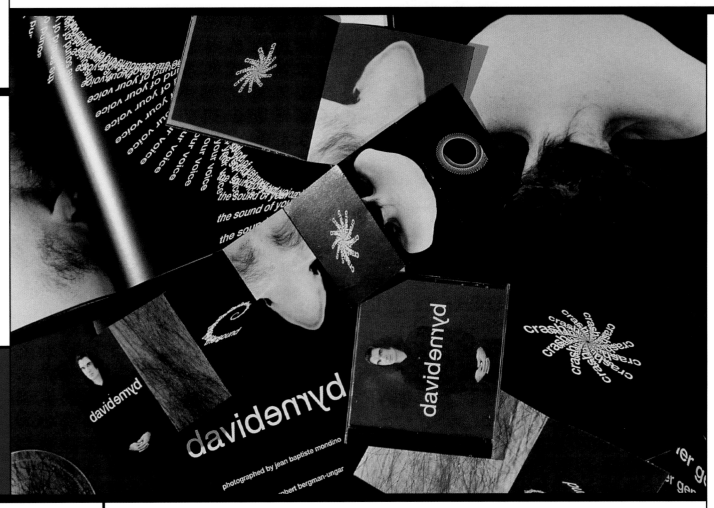

DAVID BYRNE/CD PACKAGING

creative director: Robert Bergman-Ungar; client: Warner Bros. Records; photographer: Jean Baptiste Mondino; typeface: Neue Helvetica
This package reflects David Byrne's back-to-his-roots music, which is acoustic and stripped down. The artwork includes close-ups of the hairs on Byrne's body, his dental x rays, CAT scans, microscopic views of his cells, and close-ups of his bare toes. Bergman-Ungar created "sculptures" of type shaped like cells, DNA and internal organs.

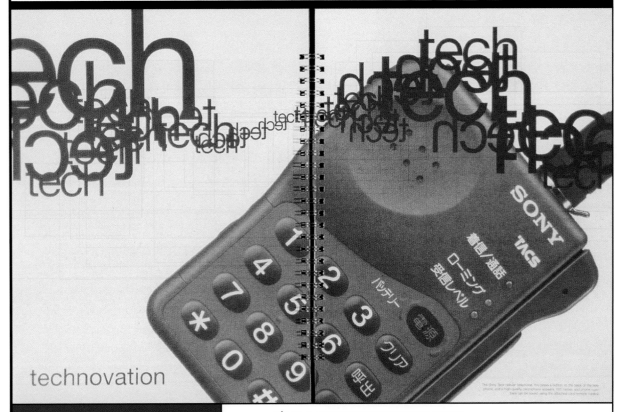

MÂP NO. 7, "TECHNOVATION"/MAGAZINE SPREAD

creative director/art director: Robert Bergman-Ungar; client: MÂP Publications; photographer: Sony Studios (Japan); typeface: Neue Helvetica family

Tracy Boychuk was born in Alberta, Canada (no, that's not next to Toronto) in 1970. She is a graduate of the Alberta College of Art and Design and completed a year of postgraduate studies at the School of Visual Arts in New York City. She began her career at Sony Music Entertainment designing horrible heavy metal singles until her first art directing opportunity. She worked on packaging for Shudder to Think, Bob Dylan, Cheap Trick, David Sanchez and Soul Asylum. Two years ago, after realizing that the five-inch square has some innate limitations, she moved on to MTV's Off-Air Creative Department, where she has worked on everything but a five-inch square. She also teaches at the School of Visual Arts.

Tracy Boychuk

1997 MTV MOVIE AWARDS
IDENTITY/STATIONERY
art direction/design: Tracy
Boychuk; client: MTV; typefaces:
various

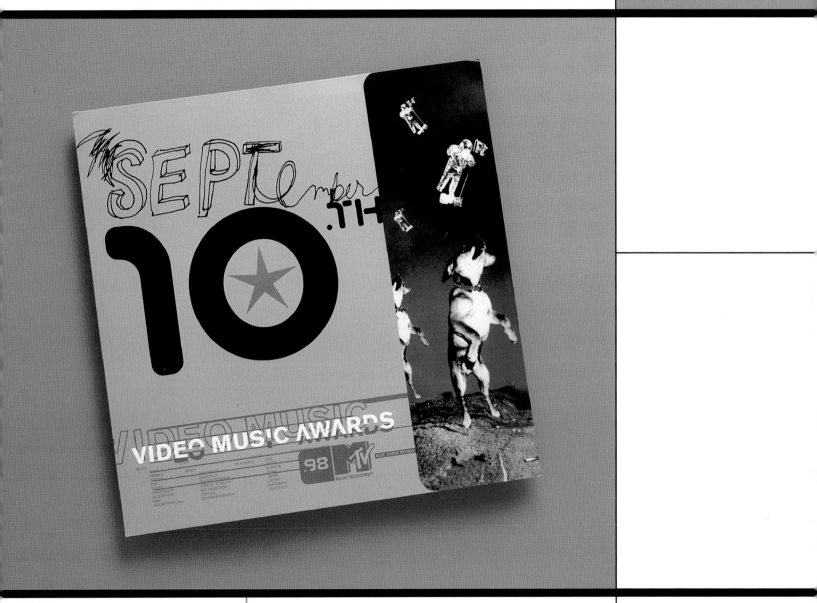

1998 MTV VIDEO MUSIC AWARDS/POSTER
art direction/design: Tracy Boychuk; client: MTV;
photographer: Jerald Frampton; typefaces: Akzidenz
Grotesk (Berthold), Aeos, custom (hand lettering)

1997 MTV MOVIE AWARDS
GUIDE/BROCHURE

creative direction: Jeffrey
Keyton; art direction/design:
Tracy Boychuk; client: MTV; pho-
tographer: Andrew Moore; type-
faces: unknown woodcut font
(sans serif), Cochin, Kuenstler,
hand lettering

This program guide, which fea-
tures nominee information, is for
the MTV Movie Awards. The theme
was inspired by the cover photo-
graph of old theater chairs.

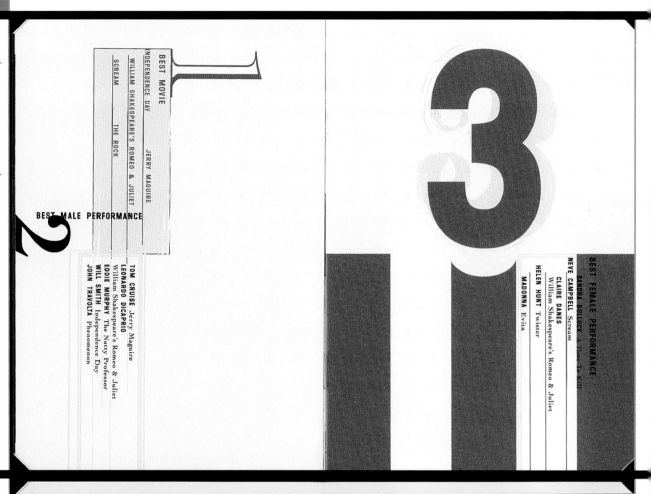

1997 MTV MOVIE
AWARDS/BROCHURE

creative direction: Jeffrey
Keyton; art direction/design:
Tracy Boychuk; client: MTV; pho-
tographer: Andrew Moore; type-
faces: unknown woodcut font
(sans serif), Cochin, Kuenstler,
hand lettering

This program guide, which fea-
tures nominee information, is for
the MTV Movie Awards. The theme
was inspired by the cover photo-
graph of old theater chairs.

Gaby Brink (along with Joel Templin) is one of the founding partners of Templin Brink Design (T.B.D.) in San Francisco. The two, who met while working at Foote, Cone & Belding's San Francisco office, joined forces in 1998 to specialize in building brands from the ground up as well as injecting new life into existing ones. Current clients include 3Com, Robert Mondavi Winery, Pixar, Qualcomm and Foote, Cone & Belding, as well as Wineshopper.com, Spinner.com, Sparks.com, and Betmaker.com in the interactive arena. In 1998 Templin and Brink were both selected to be in *Print*'s annual issue highlighting America's top twenty designers under the age of thirty.

Gaby Brink

LEVI'S
SPECIAL RESERVE
RING-SPUN
DENIM JEANS
30%
MORE INTERESTING

LYDIA HAD EVERYTHING SHE NEEDED:
A GOOD BOOK,
STRONG LUNGS
AND FRESH
Ring-Spun Denim

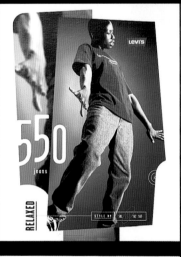

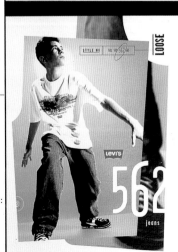

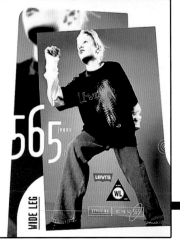

SPECIAL RESERVE
CAMPAIGN/AD
designer/art director:
Gaby Brink; client:
Levi Strauss & Co.;
photographer: Geoff
Kern; typefaces: miscellaneous woodcuts

LEVI'S POINT OF
SALE/POSTERS
designer/art
director: Gaby
Brink; client: Levi
Strauss & Co.;
photographers:
Daniel de Souza,
Dah Len; typeface:
Garage Gothic

MAGIC JOHNSON FOUNDATION, "IT ONLY
TAKES ONE"/POSTER

designer/art director: Gaby Brink; client:
Magic Johnson Foundation; photographer:
Dah Len; typefaces: Trade Gothic, Adobe
Garamond, Garage Gothic, Clarendon

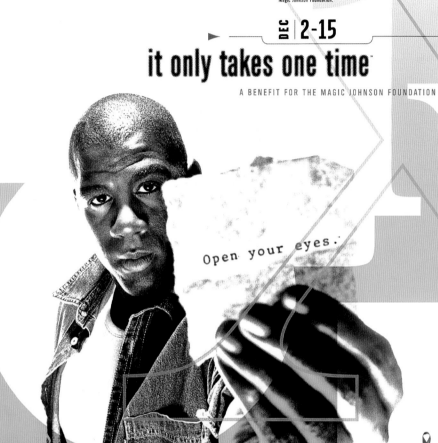

During December 2-15 a portion of all sales
from the Original Levi's Stores will benefit the
Magic Johnson Foundation, an organization
dedicated to HIV and AIDS education, care and
prevention among young people.
All proceeds from the limited edition T-shirts
and baseball caps will go directly to the
Magic Johnson Foundation.

DEC | 2-15

it only takes one time

A BENEFIT FOR THE MAGIC JOHNSON FOUNDATION

Open your eyes.

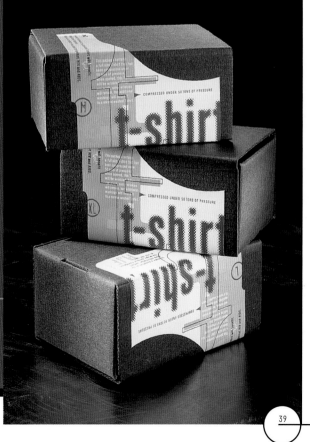

MAGIC JOHNSON FOUNDATION
COMPRESSED T-SHIRT/PACKAGING

designer/art director: Gaby Brink;
client: Magic Johnson Foundation;
typefaces: Trade Gothic, Adobe
Garamond, Garage Gothic,
Clarendon

David Calderley graduated from Wolverhampton Faculty of Art and Design and completed postgraduate studies at St. Martin's School of Art, London. As a member of the design group Stylorouge he designed album covers for diverse bands ranging from George Michael to Blur. He moved to New York City in the early 1990s, and his clients include Gee Street, Island, Virgin, Capitol, Mercury, Quango, Snowboards and Z Photographic. His work has been exhibited in the Smithsonian Institution and the Hayward Gallery in London. Currently he is the head of design for V2 Records in New York City.

David Calderley

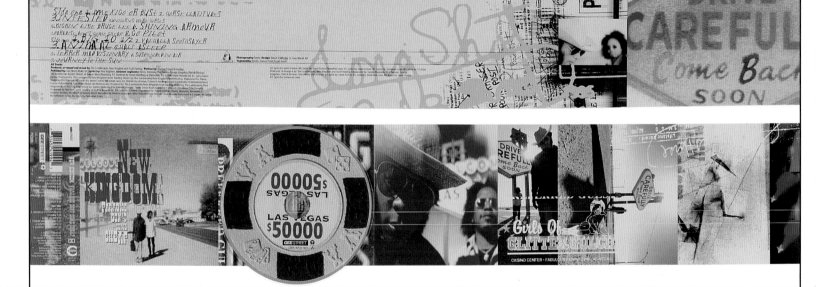

NEW KINGDOM, *PARADISE DON'T COME CHEAP/*
CD PACKAGE

designer/art director: David Calderley; client: Gee Street Records; photographer: Sanie; typefaces: found type

The band went to Las Vegas with photographer Sanie, filming a super 8 movie as well as shooting stills. These were combined with various ephemera for the artwork. The typography was sampled from a discarded betting form.

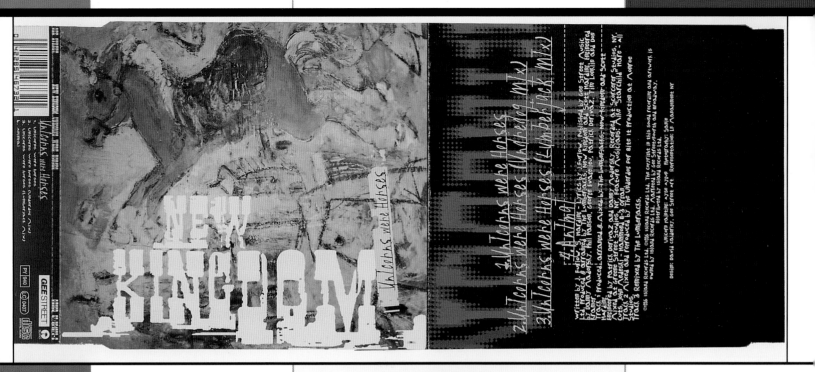

NEW KINGDOM, *UNICORNS AND HORSES*/
CD PACKAGE

designer/art director: David
Calderley; client: Gee Street
Records; painting: Ayse Agun;
typefaces: Child's Play Age
Five, Writtenhouse

JUNGLE BROTHERS, *RAW DELUXE*/CD PROMO PACKAGE

designer/art director: David Calderley; client: Gee Street Records; photographer: Donald Christie; typefaces: Egiziano Black, Neue Helvetica

The promotional package, made of aluminum, contained the advance album and video. The graphics were "stripped to the bone" with very minimal type in a generic, "information" style.

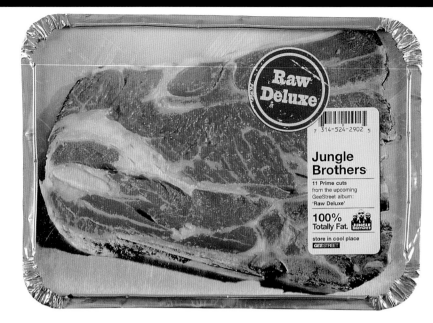

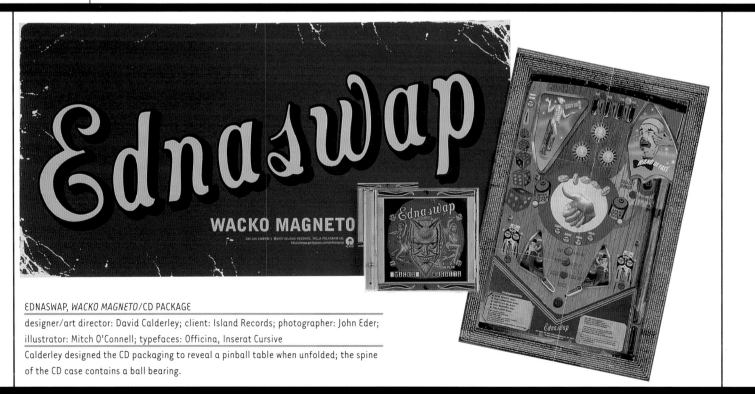

EDNASWAP, *WACKO MAGNETO*/CD PACKAGE

designer/art director: David Calderley; client: Island Records; photographer: John Eder; illustrator: Mitch O'Connell; typefaces: Officina, Inserat Cursive

Calderley designed the CD packaging to reveal a pinball table when unfolded; the spine of the CD case contains a ball bearing.

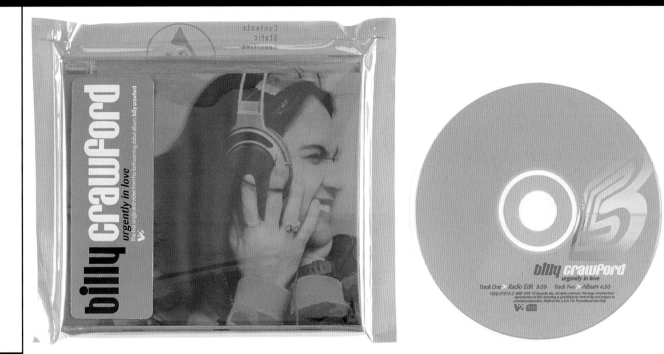

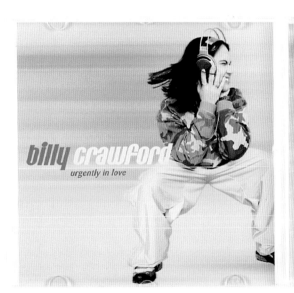

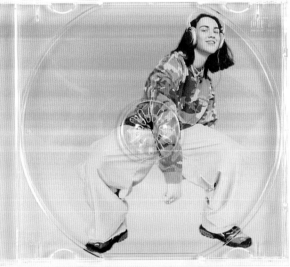

BILLY CRAWFORD,
URGENTLY IN LOVE/
CD PACKAGE
designer/art director:
David Calderley;
client: V2 Records;
photographer: Jill
Greenberg; typefaces:
Barmeno, Lithia
The promotional
package came in a
static bag that con-
tained a postcard bio
card and the CD
single. The type was
printed with metallic
inks, and the logo
was created with 3-D
strata work.

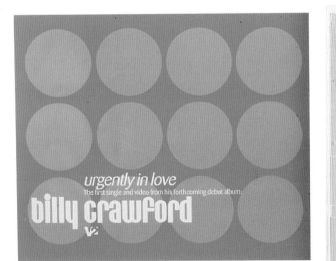

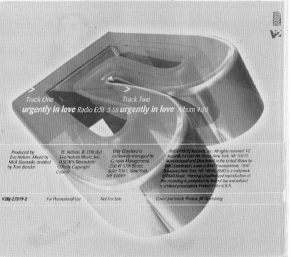

Art Chantry has received over 350 awards, including a Bronze Lion at Cannes. His work has been published in hundreds of books, magazines, catalogs, annuals, specialized publications, etc. A monograph will be published in 1999. He is the author of *Instant Litter, Concert Posters From Seattle Punk Culture*, published in 1985. Chantry has taught at Seattle's School of Visual Concepts, Seattle's Cornish School of Art, and Western Washington University. He has done weeklong stints at Kent State, Cal Arts and a few others he forgets. His exhibitions include scores of group and solo shows, including a one-man solo retrospective at the Seattle Art Museum in 1993. One poster hung in the Louvre for a short time. Cool, huh?

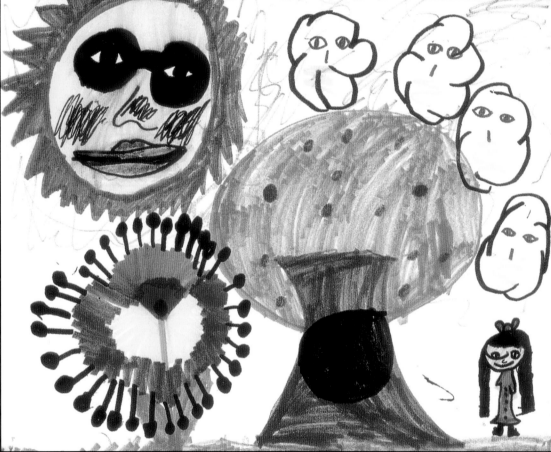

DANGER GENS, *LIFE BETWEEN CIGARETTES*/CD COVER
designer/art director: Art Chantry; client: Danger Gens; illustrator: Morgan Day, age 5 (cover); type-faces: hand lettering by Morgan Day; lyrics lettering by Danger Gens

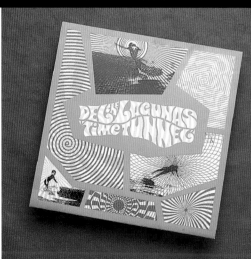

THE DEL LAGUNAS, *TIME TUNNEL*/CARD
designer/art director: Art Chantry; client: Estrus Records; photographer: unknown; type-faces: hand lettering, Franklin Gothic (altered)

"MEET THE DRAGS"/POSTCARD
designer/art director: Art Chantry; client: Estrus
Records; illustrator: unknown; typefaces:
unknown, hand lettering

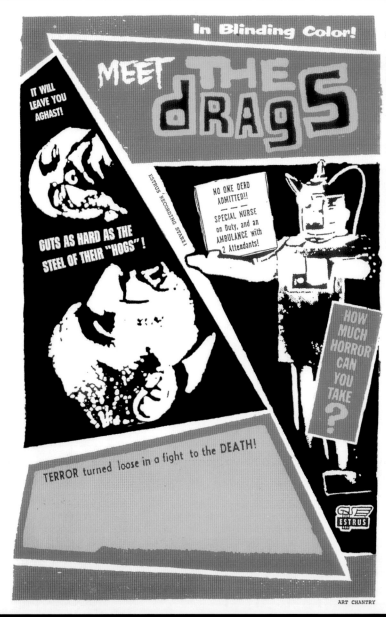

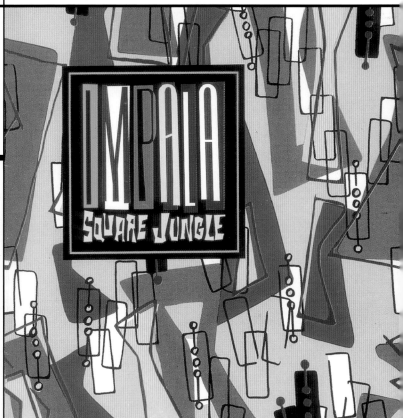

IMPALA, *SQUARE JUNGLE*/CD COVER
designer/art director: Art Chantry; client: Dave
Crider/Estrus Records; typeface: hand lettering
This design was influenced by old blues record
covers and linoleum catalogs.

HAMLET/FONT
designer/art director:
Art Chantry; client:
Chartpak
In addition to
Shakespeare's play,
Chantry credits "some-
thing [he] found that
had been left in the
ocean way too long" for
inspiring this font.

ABCDEF abcdefg
GHIJKL hijklmm
MNOPQ opqrstu
RSTUV& vwxyz'-
WXYZ;!?
1 2 3 4 5 6
7 8 9 0 $¢

Art
Chantry

HAMLET

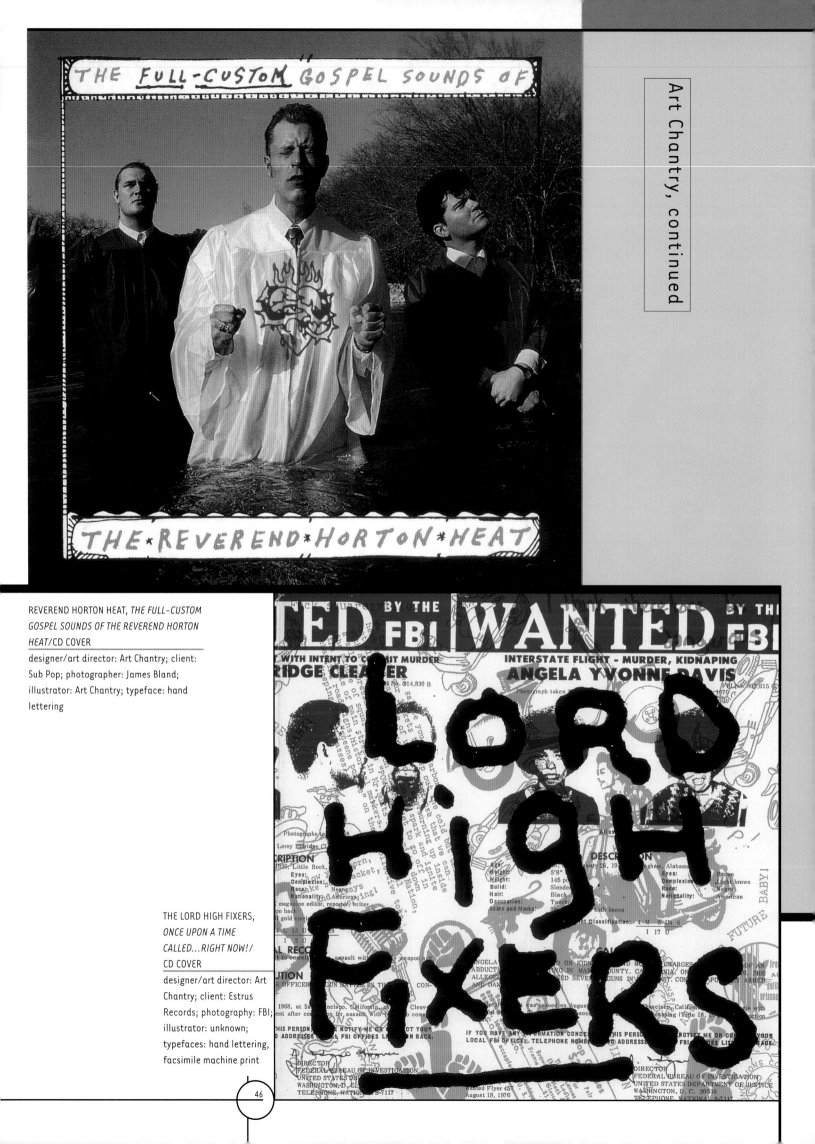

REVEREND HORTON HEAT, *THE FULL-CUSTOM GOSPEL SOUNDS OF THE REVEREND HORTON HEAT*/CD COVER

designer/art director: Art Chantry; client: Sub Pop; photographer: James Bland; illustrator: Art Chantry; typeface: hand lettering

THE LORD HIGH FIXERS, *ONCE UPON A TIME CALLED...RIGHT NOW!*/ CD COVER

designer/art director: Art Chantry; client: Estrus Records; photography: FBI; illustrator: unknown; typefaces: hand lettering, facsimile machine print

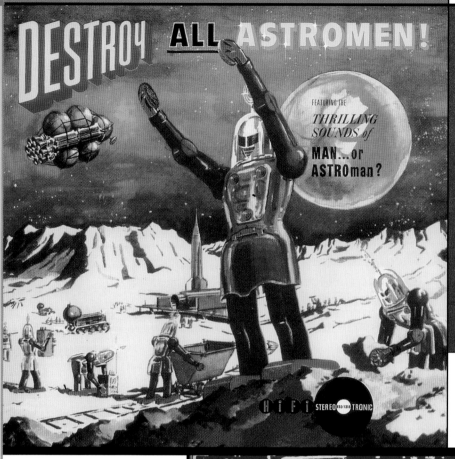

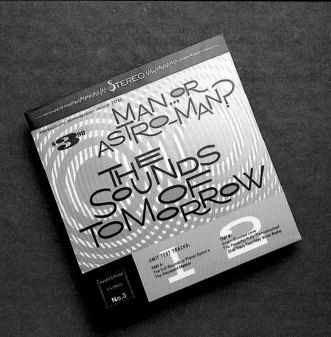

MAN...OR ASTROMAN?, *THE SOUNDS OF TOMORROW*/45 SLEEVE
designer/art director: Art Chantry; client: Estrus Records;
typefaces: hand lettering, Franklin Gothic

MAN...OR ASTROMAN?,
DESTROY ALL ASTROMEN!/
CD COVER
designer/art director: Art
Chantry; client: Estrus
Records; illustrator:
unknown; typefaces: hand
lettering, Franklin Gothic

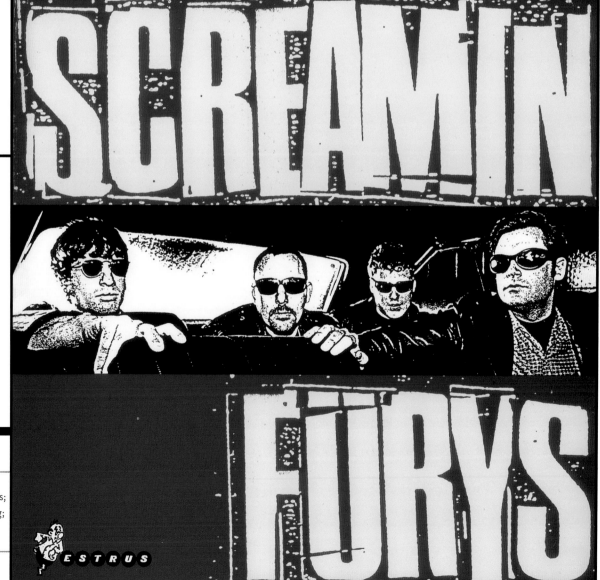

SCREAMIN' FURYS/45 SLEEVE
designer/art director: Art
Chantry; client: Estrus Records;
photographer: Charles Gullung;
typefaces: "highly altered
something or other"
"A bad drunk" served as the
basis for this gritty font.

Elan M. Cole is a founding partner of Tonic Studios, Inc., a multimedia design shop in New York City. Clients include the NBA, Marvel Comics, Parsons School of Design, Calvin Klein, USA Networks, BMG Online and more. His work has appeared at the Art Directors Club of New York, and in *Print* and *HOW* magazines. He is adept at writing dry, straightforward bios.

Elan M. Cole

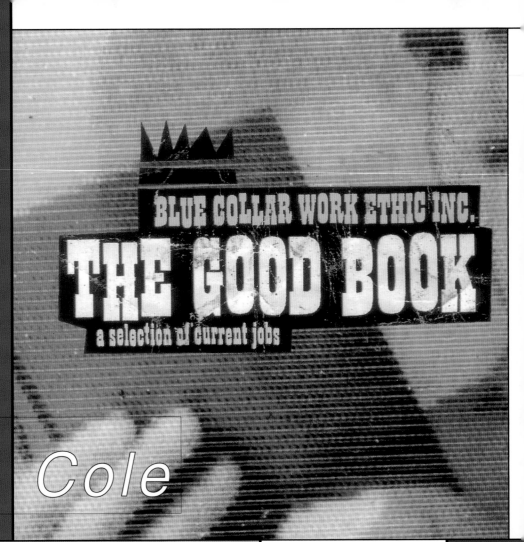

BLUE COLLAR WORK ETHIC INC.

THE GOOD BOOK

a selection of current jobs

B.C.W.E.

And they looked down and said "It is good!":

USA Networks

Vault Multimedia

Parsons School of Design

Marvel Comics

National Basketball Association

Arista Records

Fashion Cafe

The Perrier Group of America/Landor

Calvin Klein

the Sci-Fi Channel

and many more.

Blue Collar Work Ethic Inc. is a full service graphic design firm specializing in art direction, graphic design, and photo-illustration. By spreading your good name and message **we can help you make money** (amen!).

Brochures, packaging, books, new media, identity programs, posters, music packaging; depending on your business, any of these can **Make You More Money** (amen!).

After all, you cannot **MAKE EVEN MORE BUCKETLOADS OF MONEY** (amen!) if no one knows your company, product or service. For more information, or a free consultation, call 212.253.0306.

Blue Collar Work Ethic Inc: Insert clever slogan here!

BLUE COLLAR WORK ETHIC, "THE GOOD BOOK: A SELECTION OF CURRENT JOBS"/PROMOTION
designer/art director: Elan M. Cole; design studio: Tonic Studios, Inc.; client: Blue Collar Work Ethic; photography: unknown; photo-illustration: Elan M. Cole; typeface: Sagebrush

Cole created the antiqued look of wooden type and letterpress by printing out the type blocks, crumpling the paper, and then rescanning the image and compositing it in Adobe Photoshop.

scarlet
IN
glory

3

chApteR

WOLVERINE: *TRIUMPHS AND TRAGEDIES*/GRAPHIC NOVEL
designer/art director: Elan M. Cole;
design studio: Tonic Studios, Inc.;
client: Marvel Comics; penciler:
Paul Smith; colorist: Glynis Oliver;
photo-illustration: Elan M. Cole;
typeface: Crackhouse

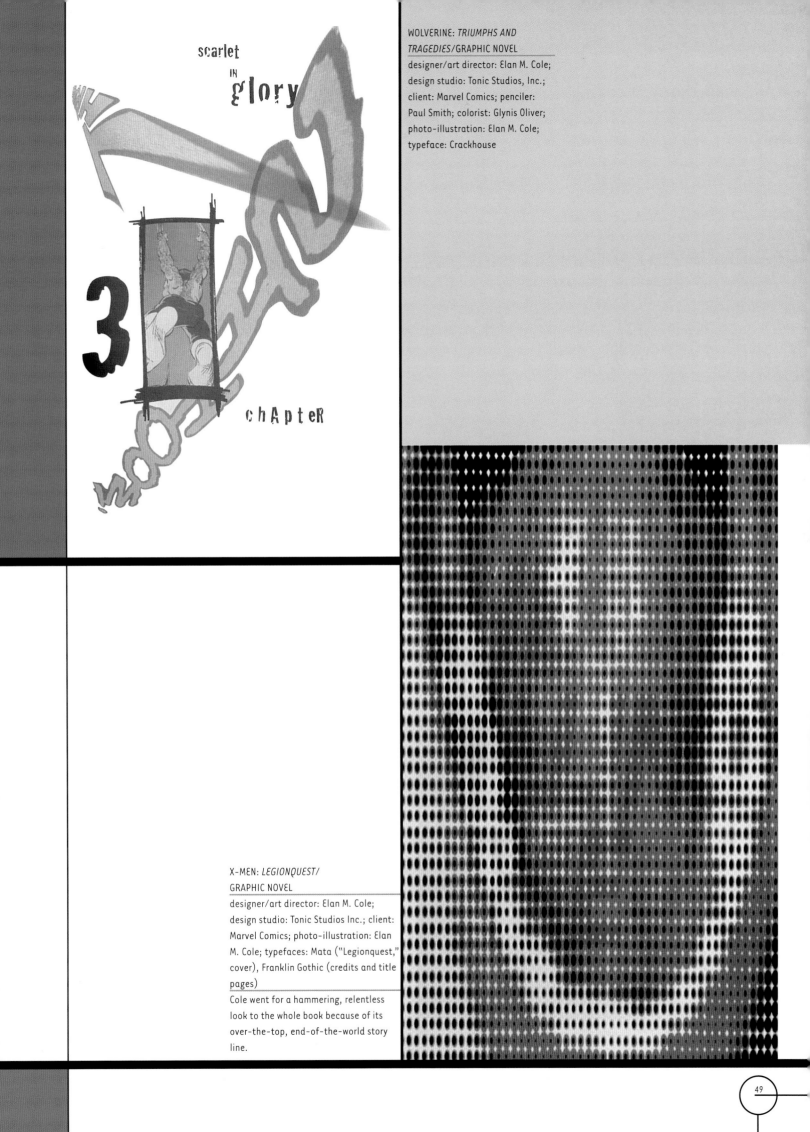

X-MEN: *LEGIONQUEST/*
GRAPHIC NOVEL
designer/art director: Elan M. Cole;
design studio: Tonic Studios Inc.; client:
Marvel Comics; photo-illustration: Elan
M. Cole; typefaces: Mata ("Legionquest,"
cover), Franklin Gothic (credits and title
pages)
Cole went for a hammering, relentless
look to the whole book because of its
over-the-top, end-of-the-world story
line.

THE ORIGIN OF GENERATION X/GRAPHIC NOVEL
designer/art director: Elan M. Cole; design
studio: Tonic Studios, Inc.; client: Marvel
Comics; pencils: Andy Kubert; inks: Matt Ryan;
letters: Bill Oakley; typeface: Bedrock

Elan M. Cole, continued

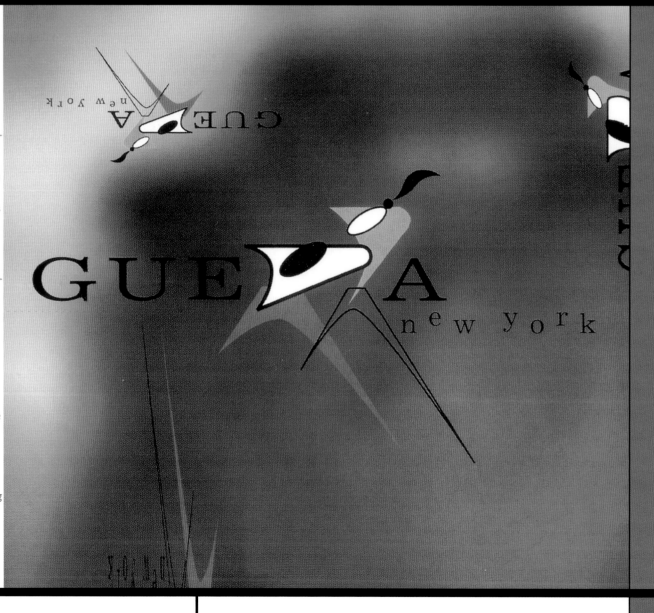

GUERRA NEW
YORK/LOGO
designer/art
director: Elan M.
Cole; design studio:
Tonic Studios, Inc.;
client: Guerra Men's
Wear, New York;
illustrator: Elan M.
Cole; typeface:
custom

To match the
swanky, loungy
clothes of this
clothier, Cole went
for "an almost
Über-Swinger
aesthetic: big
collars, satin
electric colors." The
two *Rs* in the logo
are a man and
woman lost in a
dancing groove.
Cole has been trying
to come up with a
name for the font
he designed;
GrooveKing "seems
to be it for now."

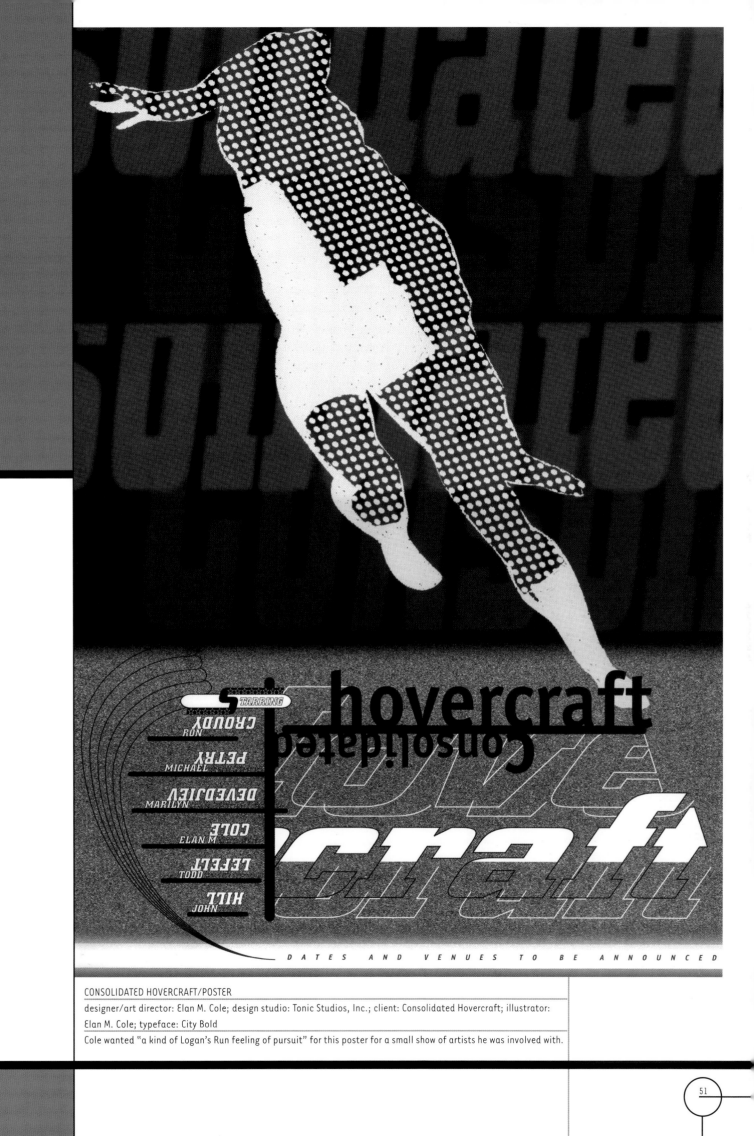

hovercraft

Consolidated

STARRING
RON CROUDY
MICHAEL PETRY
MARILYN DEVEDJIEV
ELAN M COLE
TODD LEFELT
JOHN HILL

DATES AND VENUES TO BE ANNOUNCED

CONSOLIDATED HOVERCRAFT/POSTER
designer/art director: Elan M. Cole; design studio: Tonic Studios, Inc.; client: Consolidated Hovercraft; illustrator:
Elan M. Cole; typeface: City Bold
Cole wanted "a kind of Logan's Run feeling of pursuit" for this poster for a small show of artists he was involved with.

David Crow

David Crow's career in design includes experience in books, packaging, advertising and academia. He has worked for Island Records London and as a freelance graphic designer, where his clients included Sony, Virgin, RCA, Royal Shakespeare Co. and GCK Advertising. He is currently the head of the department of graphic arts, Liverpool Art School, at Liverpool John Moores University.

let us go down and
הבה נרדה
confound their language
את שפתם אשר
that they may not
לא ישמעו איש
understand one another's
שפת רעהו
speech

DIALOGUE/FONT
designers: David Crow, Yaki Molcho
(Tel Aviv Centre for Design Studies);
client: Liverpool Art School
This is a dual alphabet font that con-
tains both the Roman and Hebrew
alphabets.

52

MEGA FAMILY LEISURE/FONT

designer: David Crow; client: *FUSE* (issue 16, 1996)

This experimental font contains fragments of two portraits: a male portrait on the uppercase keys and a female portrait on the lowercase keys. By typing a mix of upper- and lowercase, a new portrait is made using elements of both "parents."

work typograph**typography** leisure

introducing **the trouble group of companies an international corporation of ordinary individuals**

TROUBLE/IMAGE

designer: David Crow; client: self; typefaces: custom

These images were created for a personal research project, a CD-ROM entitled *Forest of Signs 1997.*

Doyle Partners merges expertise in graphic design, communications, advertising and marketing in a small studio environment. After thirteen years, its staff of twelve continues to impress a broad roster of clients with design concepts that are active and engaging, implemented with discipline and imagination. The variety of projects keeps the thinking and the work fresh; limiting the number of projects keeps a focus on the needs of the client. Originally founded as Drenttel Doyle Partners, this is a studio where identity programs, collateral material, advertising, magazines, catalogs, books, CDs, installations, signage and products are created simultaneously for a varied clientele.

Stephen Doyle

19TH AMENDMENT INSTALLATION/DISPLAY

art directors: Stephen Doyle, Miguel Oks, William Drenttel; designers: Lisa Yee, James Hicks; design studio: Drenttel Doyle Partners; client: New York State Division for Women; photographer: Scott Frances; typefaces: Bureau Grotesque, Franklin Gothic

This installation commemorated the 75th anniversary of the ratification of the 19th amendment, which gave women the right to vote.

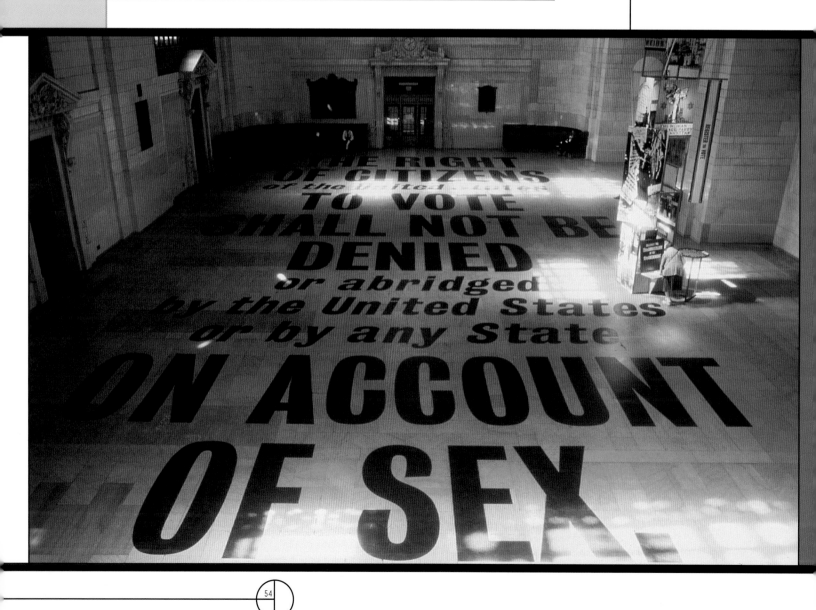

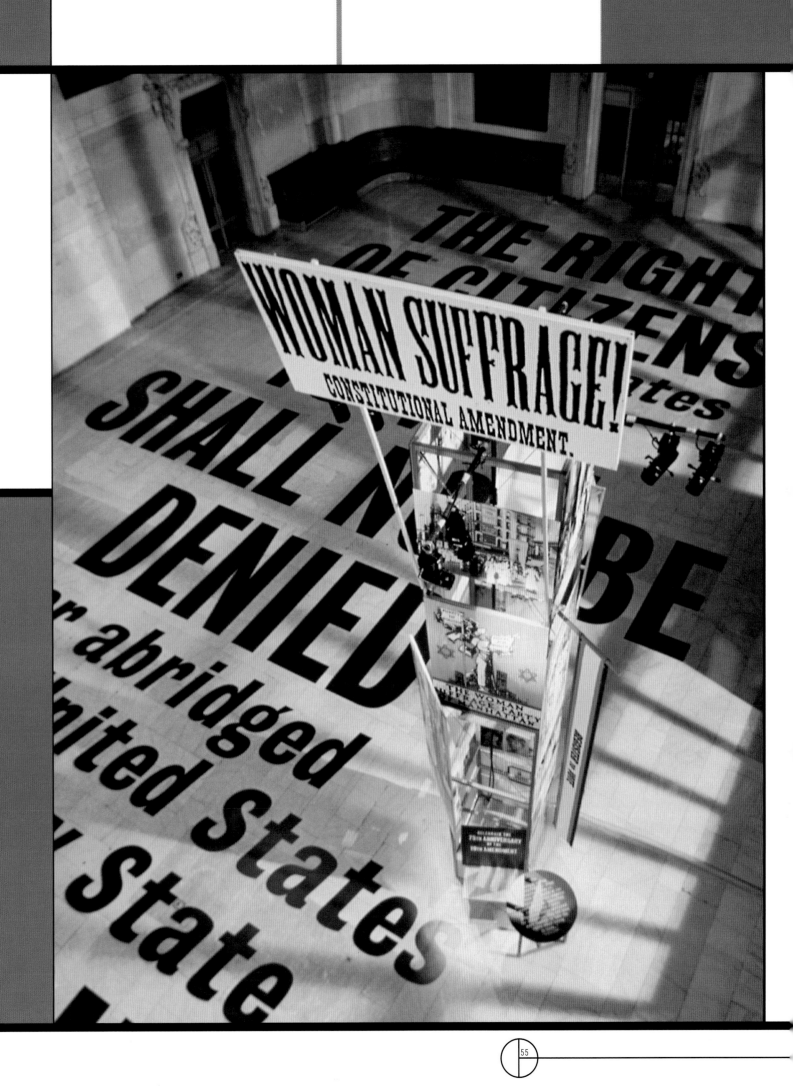

WRITTEN REACTION

POETICS POLITICS POLEMICS

Eliot Weinberger

Marsilio

WRITTEN REACTION/BOOK JACKET
art director: Stephen Doyle; design studio: Doyle Partners;
client: Marsilio Publishers; photographer: Stephen Doyle;
typefaces: found type (plastic letters), Sabon

The Book of Lamentations

Rosario Castellanos

TRANSLATED BY

ESTHER ALLEN

Marsilio

THE BOOK OF
LAMENTATIONS/BOOK JACKET
art director: Stephen Doyle;
design studio: Doyle Partners;
client: Marsilio Publishers;
photographer: Stephen Doyle;
typefaces: Sabon, hand-
drawn Sabon
The title was hand painted
onto cloth, which was then
draped and photographed.

Hans Deichmann

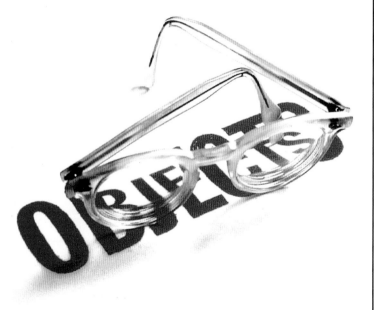

A CHRONICLE OF SUBVERSION
IN NAZI GERMANY AND FASCIST ITALY

Marsilio

OBJECTS/BOOK JACKET
Designer/art director: Stephen
Doyle; design studio: Doyle
Partners; client: Marsilio
Publishers; typefaces: Sabon,
Franklin Gothic

Joe Duffy heads the design discipline for Fallon McElligott companies, including Duffy Design and Revolv. Chances are you have Duffy work in your home right now—Diet Coke, Minute Maid, Booker's Bourbon or a Yakima rack on the roof of your car. Duffy's work includes brand and corporate identity development for leading companies from Armani to BMW to M&M/Mars to Porsche to McDonald's to Coca-Cola. His understanding of how design affects consumer attitudes has led to many big ideas executed in advertising, as well as design. The Gallery Von Oertzen in Frankfurt has exhibited Duffy's work, as has London's Victoria & Albert Museum. He has lectured on design throughout the U.S., Europe and Australia.

Duffy Design

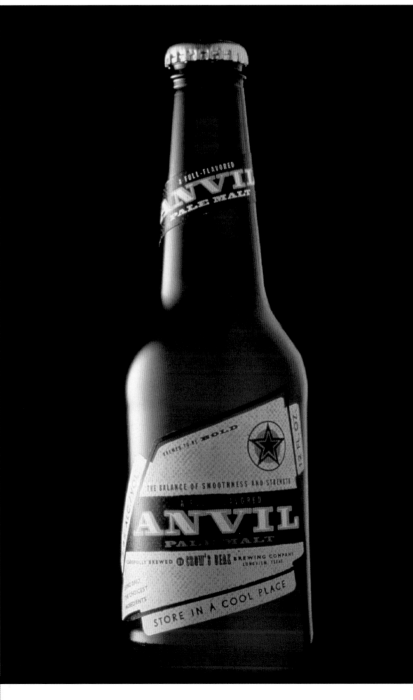

PALE MALT ANVIL/PACKAGING
creative director: Joe Duffy;
designer: Kobe; design studio:
Duffy Design; client: Stroh
Brewery; typefaces: various
Anvil was designed to avoid being
too trendy or ethnically oriented
in order to ensure a longer product life and be perceived as an
"OK" brand by the targeted
young, male, blue-collar market.

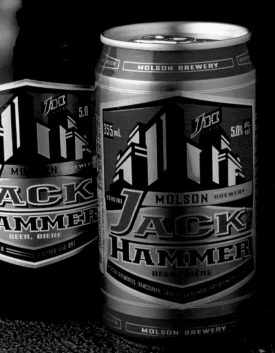

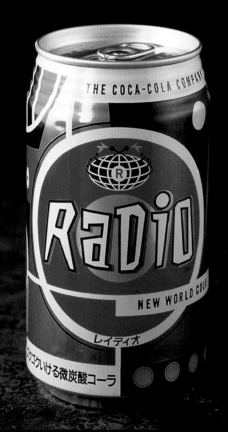

Giles Dunn

Giles Dunn's career started in 1990 in England at the Neville Brody studio, where he was involved until 1995 in international projects in all fields. He now lives and works in New York, heading the design department of the U.S./U.K. company Punkt, a multidisciplinary group encompassing music, photography, design and film projects on both sides of "the pond." His work includes film projects for Nickelodeon, editorial design for *Wired Magazine* and an association with Japanese composer Ryuichi Sakamoto as his U.S. art director. Dunn's work is included in the permanent collections of the Victoria & Albert Museum, London, and the Cooper-Hewitt, National Design Museum, New York.

LOVE IS THE DEVIL
Original Soundtrack Recording
Music Composed, Performed and Produced by RYUICHI SAKAMOTO

333, *SEED*/POSTER
art direction/design: Giles Dunn; design studio: Punkt; client: Güt Bounce Records (Tokyo); photography: Giles Dunn; typefaces: Pop (logo); Akzidenz Grotesk (text)
For 333's debut album, Dunn contrasted a very industrially inspired graphic structure with organic imagery. Pop, used for the logo, has the suitable industrial austerity needed.

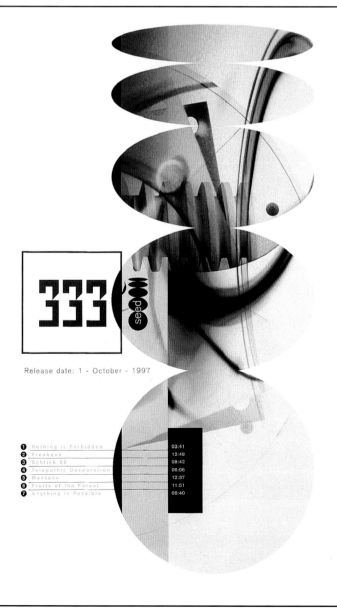

333 seed

Release date: 1 - October - 1997

❶ Nothing is Forbidden		03:41
❷ Freakque		12:48
❸ Schlick 50		08:42
❹ Telepathic Desperation		06:06
❺ Montana		12:37
❻ Fruits of the Forest		11:51
❼ Anything is Possible		08:40

RYUICHI SAKAMOTO, *LOVE IS THE DEVIL* SOUNDTRACK/POSTER
art direction: Giles Dunn; design studio: Punkt; client: Aspodel Records; still photography: Denise Milford over portraits courtesy of The BFI; typeface: Akzidenz Grotesk
For this soundtrack to a movie about Francis Bacon, Dunn chose to contrast the mood of Bacon's paintings by creating something very stripped down with the Swiss antiseptic cleanliness of the Akzidenz Grotesk font, which echoes the precision of Sakamoto's music. The dark and distorted visual signature of the painter is evoked rather than copied.

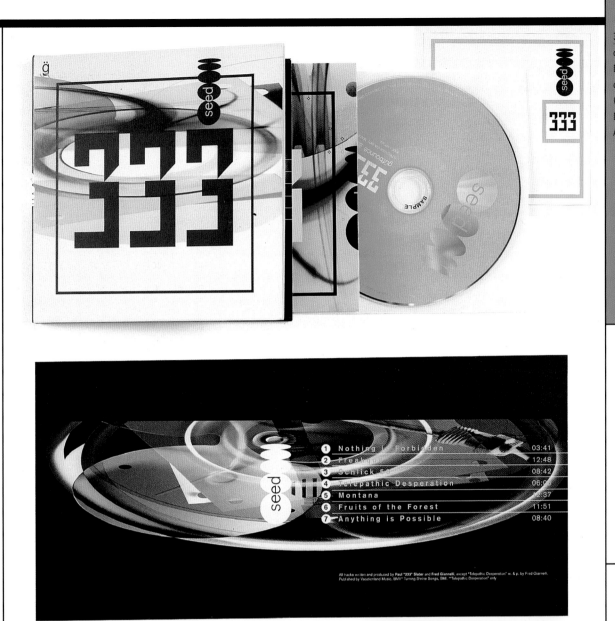

333, *SEED*/DIGI-PAC PACKAGE
art direction/design: Giles
Dunn; design studio: Punkt;
client: Güt Bounce Records
(Tokyo); photography: Giles
Dunn; typefaces: Pop (logo);
Akzidenz Grotesk (text)

① Nothing is Forbidden 03:41
② Freakque 12:48
③ Schlick 50 08:42
④ Telepathic Desperation 06:06
⑤ Montana 12:37
⑥ Fruits of the Forest 11:51
⑦ Anything is Possible 08:40

333, *SEED*/CD PACKAGE
art direction/design: Giles
Dunn; design studio: Punkt;
client: Güt Bounce Records
(Tokyo); photography: Giles
Dunn; typefaces: Pop (logo);
Akzidenz Grotesk (text)

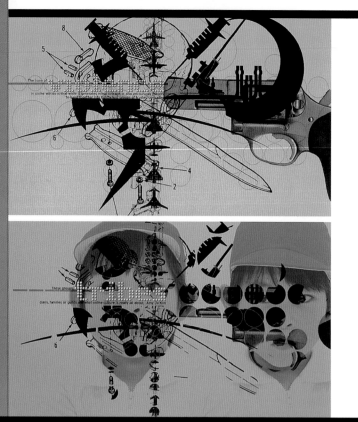

WIRED, MAY 1998, "KILLERS HAVE MORE FUN"/INTRODUCTION PAGES

art direction/design: Giles Dunn; design studio: Punkt; client: *Wired Magazine*; writer: Amy Jo Kim; photography: Photonica; typeface: dot matrix (custom) (display type), Interstate (text)

To illustrate an article on the nature of violence on the Internet, Dunn imposed various pictograms and a circular grid on two innocent-looking Japanese boys to convey the idea of violence.

THE HAFLER TRIO, *THE GOLDEN HAMMER*/6-CD SET

art direction/design: Giles Dunn; design studio: Punkt; client: The Grey Area of Mute Records (London); photography: Giles Dunn; typeface: Akzidenz Grotesk

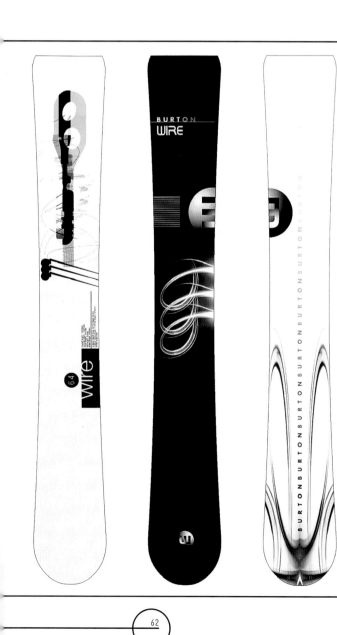

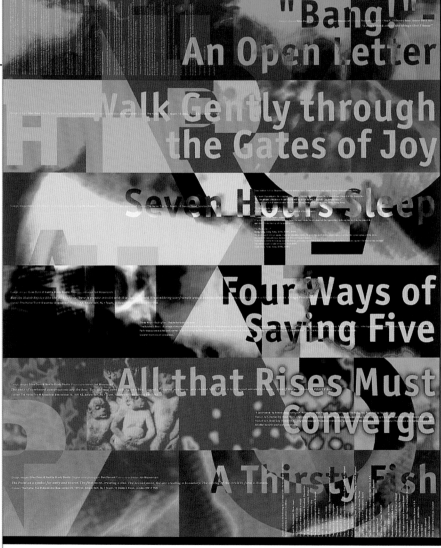

BURTON ALPINE RACING SNOWBOARDS/SNOWBOARDS

art direction/design: Giles Dunn; design studio: Punkt; client: Jager Di Paola Kemp; photography: Giles Dunn; typeface: DIN

These alpine race boards were commissioned for the 1998 Winter Olympics. The imagery consists of a mixture of photographic rayograms—delayed time exposures using flashlights, flares and shaken colored liquids. Dunn felt that the boards required a certain sophistication for their Olympic debut, which was the opposite of people's preconceived ideas about snowboards.

art direction/design: Giles Dunn; design studio: Punkt; client: Haus der Kulturen der Welt (Berlin); photography: Giles Dunn; typeface: Bank Gothic

For this poster (for a Brazilian event) and the Indian Dance Festival poster, Dunn had to work within tight deadlines and small budgets. This required an intuitive approach to convey the spirit of the events, which Dunn did by using a contemporary Western aesthetic to reinterpret world music to attract a new audience.

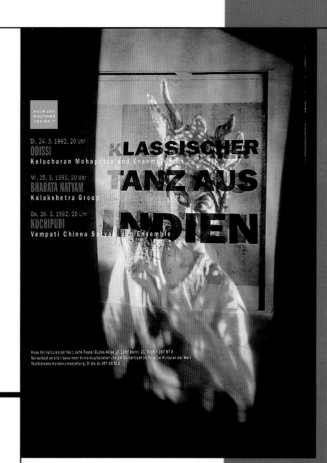

KLASSISCHER TANZ AUS INDIEN (INDIAN DANCE FESTIVAL)/POSTER

art direction/design: Giles Dunn; design studio: Punkt; client: Haus der Kulturen der Welt (Berlin); photography: Giles Dunn; typeface: Franklin Gothic

Haus der Kulturen der Welt is a cultural institution in Berlin that hosts events from around the world. This was the final poster in a series of Indian dance performance posters.

WIRED, FEBRUARY 1999, "ONE-EYED ALIENS! SUICIDE BOOTHS! MOM'S OLD-FASHIONED ROBOT OIL!"/INTRODUCTION PAGES

art direction/design: Giles Dunn; design studio: Punkt; client: *Wired Magazine*; writer: Matt Groening; photographer: Giles Dunn; typeface: Armada

A series of separate images representing "mythologies" are introduced on the first spread; these then expand and are brought to life through "devotion" on the second spread.

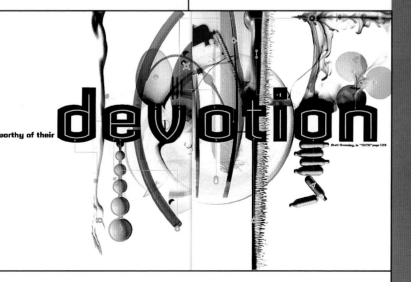

52mm formed in August 1996 as a creative collaboration for its partners, Marilyn Devedjiev and John J. Hill, who hail from Chicago and Detroit, respectively. Thus far they have shown work in the Low Res Film Festival, the Art Director's Club New York and "Motion Graphics '98" at the Axis Gallery in Tokyo. They work in digital illustration, film and video graphics, print, new media and digital sound design. Clients include the National Hockey League, MTV Online, Loud Records, The Alternative Pick and Top Cow Productions.

UNTITLED, *FREE THE FUNK*/ILLUSTRATION FOR CD

art director/designer: John J. Hill; design studio: 52mm; client: R+S Records (Belgium); illustrator: John J. Hill; typefaces: found type

The custom fonts were based on New York City graffiti and type on a moving bus.

1

MIHO KOMATSU, "CHANCE"/VIDEO
creative consultant: Matthew Waldman; art directors: Marilyn Devedjiev, John J. Hill; designer: Marilyn Devedjiev; design studio: 52mm; client: NY Zoom; cinematographer: John J. Hill; typeface: Baby Mine
Baby Mine was chosen because it reminded the designers of "soft, bubbly, sugary sweet Japanese pop."

2

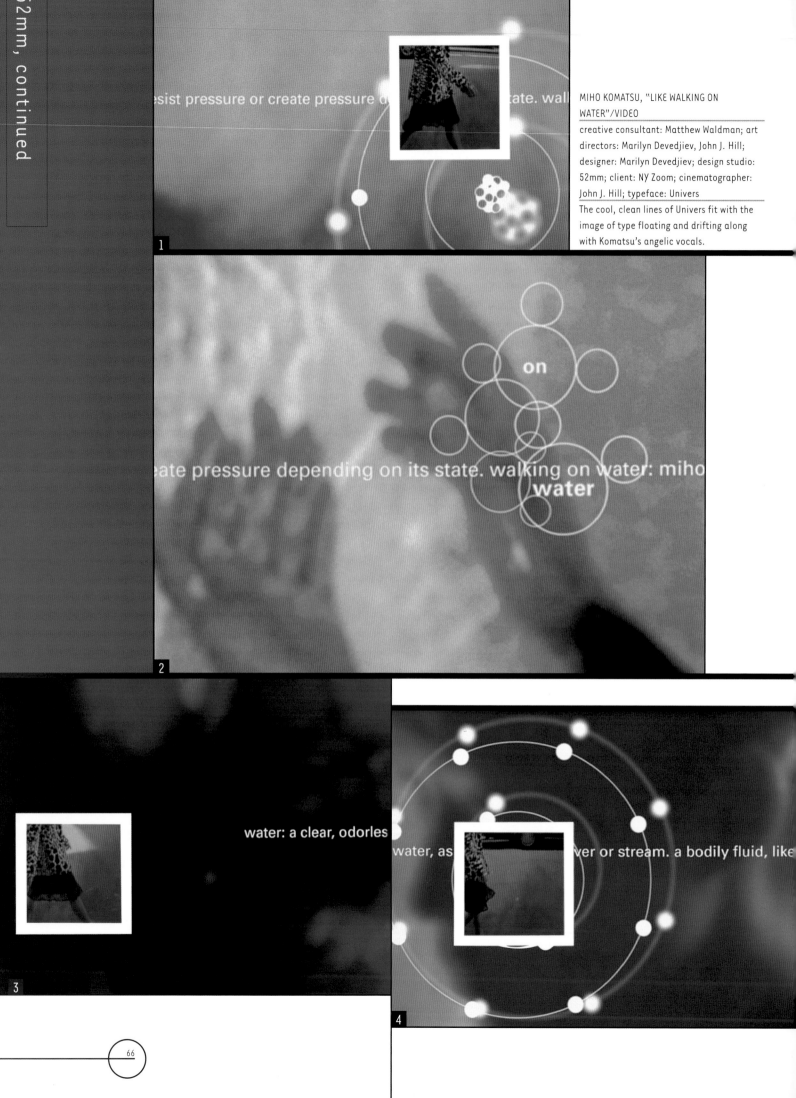

esist pressure or create pressure d... ...ate. wal...

1

MIHO KOMATSU, "LIKE WALKING ON WATER"/VIDEO

creative consultant: Matthew Waldman; art directors: Marilyn Devedjiev, John J. Hill; designer: Marilyn Devedjiev; design studio: 52mm; client: NY Zoom; cinematographer: John J. Hill; typeface: Univers

The cool, clean lines of Univers fit with the image of type floating and drifting along with Komatsu's angelic vocals.

on

water

...ate pressure depending on its state. walking on water: miho

2

water: a clear, odorles...

water, as ...ver or stream. a bodily fluid, like

3

4

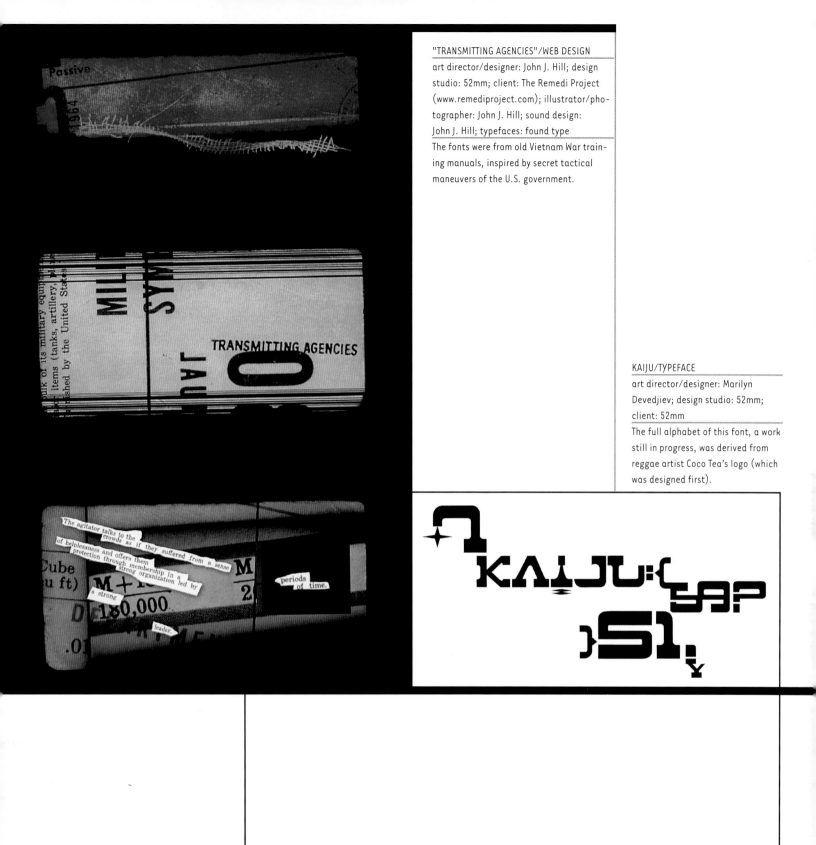

"TRANSMITTING AGENCIES"/WEB DESIGN
art director/designer: John J. Hill; design
studio: 52mm; client: The Remedi Project
(www.remediproject.com); illustrator/pho-
tographer: John J. Hill; sound design:
John J. Hill; typefaces: found type
The fonts were from old Vietnam War train-
ing manuals, inspired by secret tactical
maneuvers of the U.S. government.

KAIJU/TYPEFACE
art director/designer: Marilyn
Devedjiev; design studio: 52mm;
client: 52mm
The full alphabet of this font, a work
still in progress, was derived from
reggae artist Coco Tea's logo (which
was designed first).

COCO TEA/LOGO
art directors: Marilyn Devedjiev, David Harley; designer:
Marilyn Devedjiev; design studio: 52mm; client: Motown
Records; typeface: Kaiju
This logo served as the basis for the design of the rest
of the alphabet for the Kaiju (which means "giant
monster" in Japanese) font.

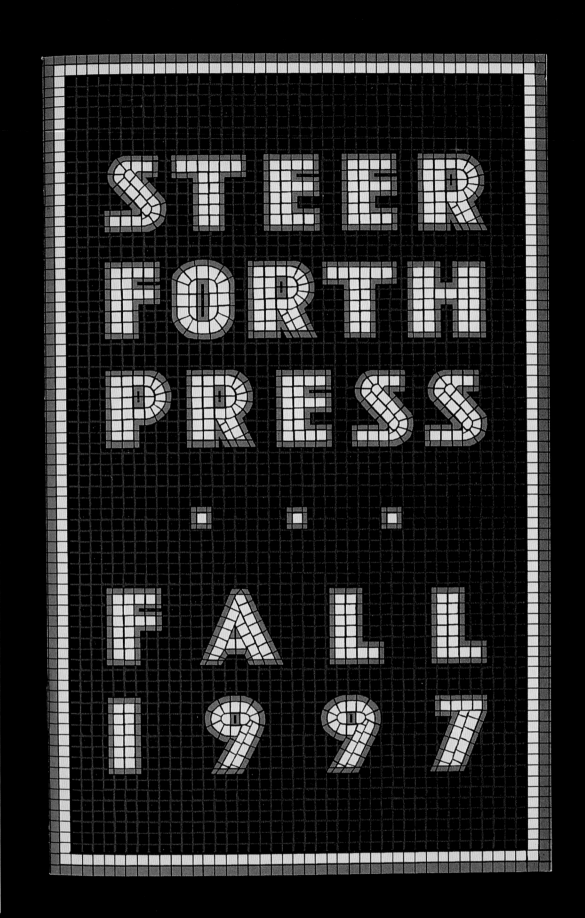

STEER FORTH PRESS ... FALL 1997

STEERFORTH/CATALOG

art director: Louise Fili; designers: Louise Fili, Tonya Hudson; design studio: Louise Fili Ltd.;

client: Steerforth Press; typefaces: hand lettering

Fili based this design on mosaic type used in the New York City subway system.

Louise Fili was a senior designer for Herb Lubalin during the late 1970s. Later, as art director of Pantheon Books, Fili designed over two thousand book jackets. Her numerous awards include Gold and Silver Medals from the New York Art Directors Club and the Society of Illustrators, and the Premio Grafico from the Bologna Book Fair. She also received a National Endowment for the Arts grant to study the work of W.A. Dwiggins. In 1989 she founded Louise Fili Ltd., which specializes in logo, package, restaurant, type, and book and book jacket design.

METROPOLE

METROPOLE/LOGO
art director/designer: Louise Fili; design studio: Louise Fili Ltd.; client: Metropole restaurant; typeface: Bifur (computer altered)
Bifur was designed by A.M. Cassandre.

BOLIVAR/LOGO
art director: Louise Fili; designers: Louise Fili, Mary Jane Callister; design studio: Louise Fili Ltd.; client: Bolivar restaurant; typefaces: hand lettering
Spanish type from the 1930s served as the influence for this logo.

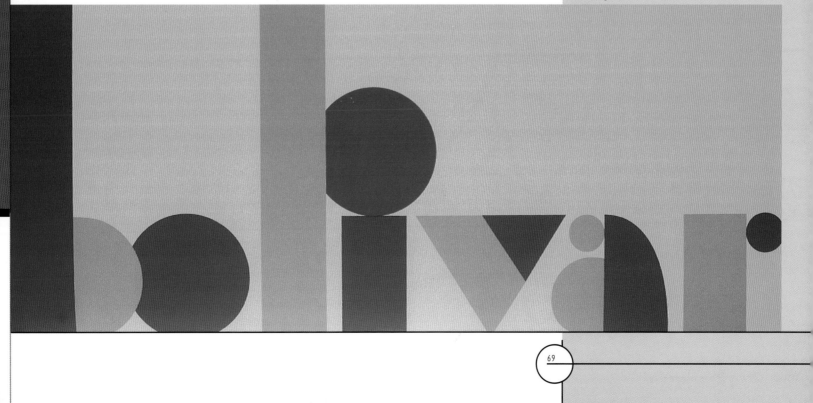

LOUISE FILI: CINCINNATI/POSTER
art director/designer: Louise Fili;
design studio: Louise Fili Ltd.; client:
Art Directors Club of Cincinnati;
photographer: Ed Spiro; typefaces:
Futura Book, OptiExcelsior

LOUISE FILI CINCINNATI

Now that espresso
has come to Cincinnati,
Louise Fili has left her cappuccino
machine behind to venture west for an
evening's engagement at the Art
Directors Club of Cincinnati.
Cincinnati Art Museum.
September 20th.

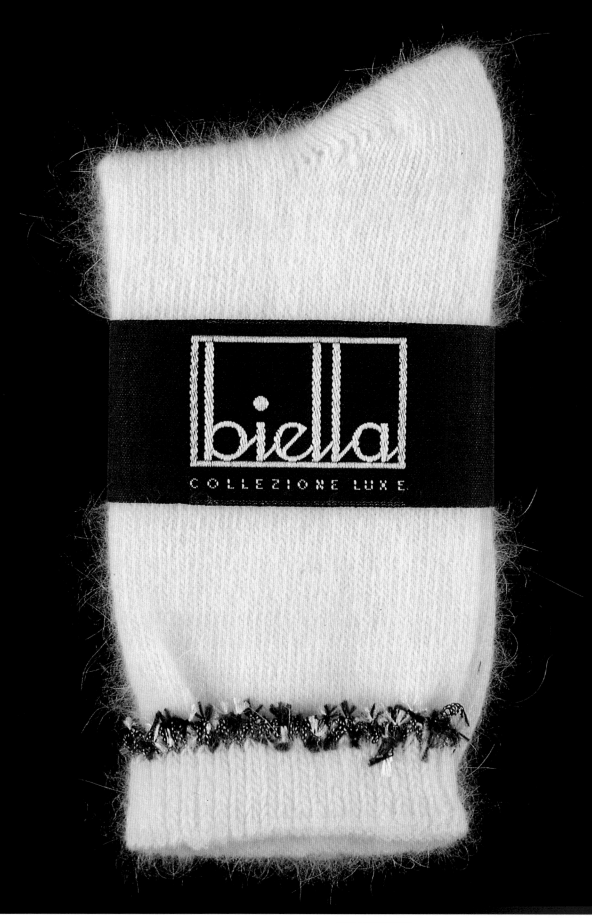

BIELLA/PACKAGING

art director/designer: Louise Fili; design studio: Louise Fili
Ltd.; client: Biella; typefaces: hand lettering

Fili was inspired by Italian scripts from the 1930s for this
type.

Firehouse 101 Art + Design creates graphic design and illustration that challenges traditional definitions, attempting to become more intuitive as art in its communication. The studio goes beyond basic problem solving to introduce elements of spontaneity and passion within the communication process. Firehouse 101 Art + Design specializes in full-service design and illustration, including logo identity branding, CD packaging, brochures, posters, animation, fashion wear and Web design.

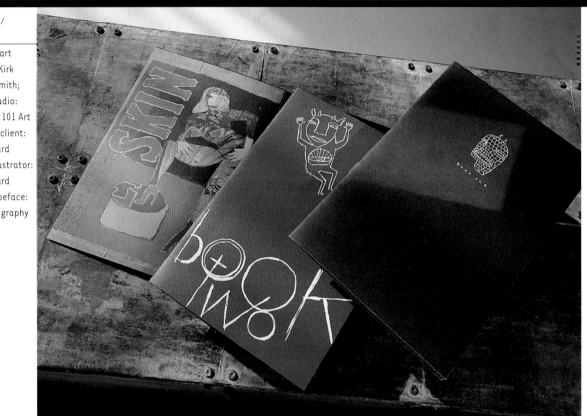

BOOK TWO/ BOOKLET
designer/art director: Kirk Richard Smith; design studio: Firehouse 101 Art + Design; client: Kirk Richard Smith; illustrator: Kirk Richard Smith; typeface: hand calligraphy

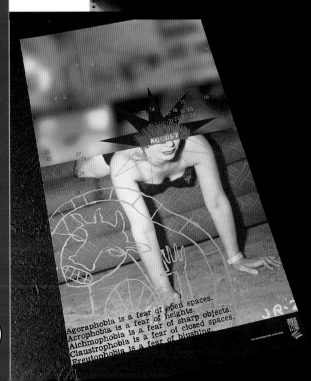

"AUGUST"/POSTER
designer/art director: Kirk Richard Smith; design studio: Firehouse 101 Art + Design; client: Byrunn Litho; photographer: unknown; illustrator: Kirk Richard Smith; typefaces: Avenir family (dates and "the first Friday falls on the first")

Found typography from a Latin book on love was cut and reassembled ("August"). The text in the lower left-hand corner was photocopied from a 1950s men's magazine.

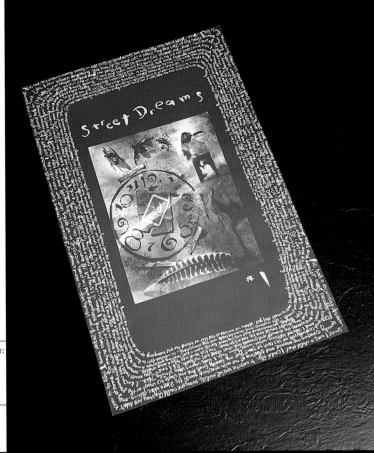

"STREET DREAMS"/POSTER
designer/art director: Kirk Richard Smith; design studio:
Firehouse 101 Art + Design; client: Columbus Society of
Communicating Arts (CSCA); photographer: Steve
Webster; typeface: hand calligraphy
For the hand calligraphy, Smith used India ink on both
parchment and cement.

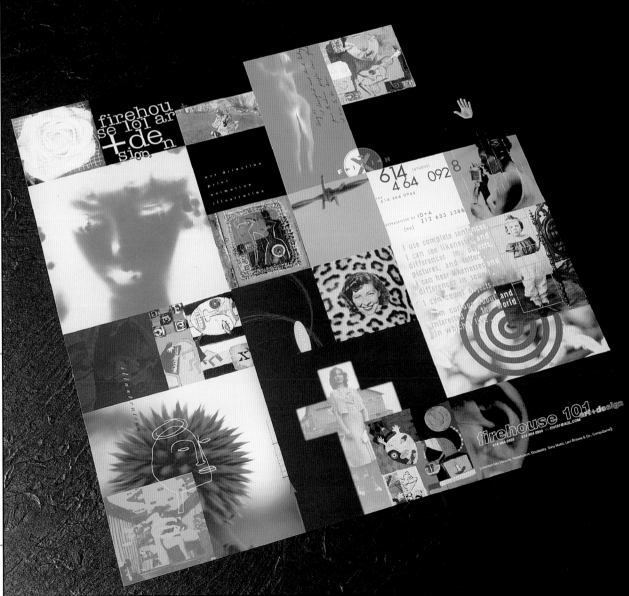

ALTERNATIVE PICKS/AD
designer/art director: Kirk
Richard Smith; design studio:
Firehouse 101 Art +
Design; client: Firehouse 101 Art +
Design; photographer: Will
Shively; illustrator: Kirk Richard
Smith; typefaces: typewriter font
("Firehouse 101 Art + Design");
Avenir family (phone numbers
and address); found type ("i use
complete sentences"); hand
lettering
The handwritten type is from Kirk
Richard Smith's grandmother's
journal.

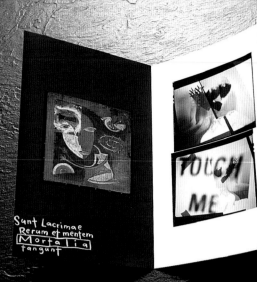

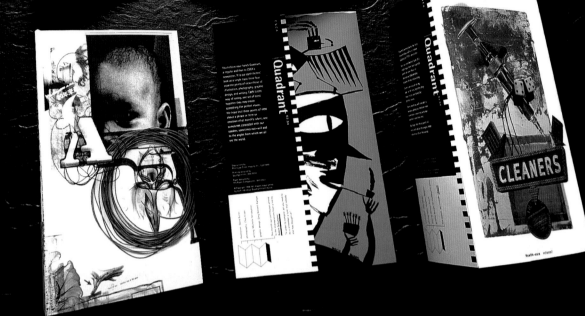

COLUMBUS SOCIETY OF
COMMUNICATING ARTS,
QUADRANT/MAILING

art directors: Kirk Richard Smith,
Oscar Fernández, Christopher M.
Jones, Stephen Webster; designers:
Oscar Fernández (format), Kirk
Richard Smith (layout); design
studio: Firehouse 101 Art + Design;
client: Columbus Society of
Communicating Arts (CSCA);
photographers: Will Shively, John
Weber; illustrators: Kirk Richard
Smith, Todd Sines, Keith Novicki,
David Butler; typefaces: hand
calligraphy ("sunt Lacrimae"),
Rotis family ("Quadrant" and body
copy), stencil type ("A")

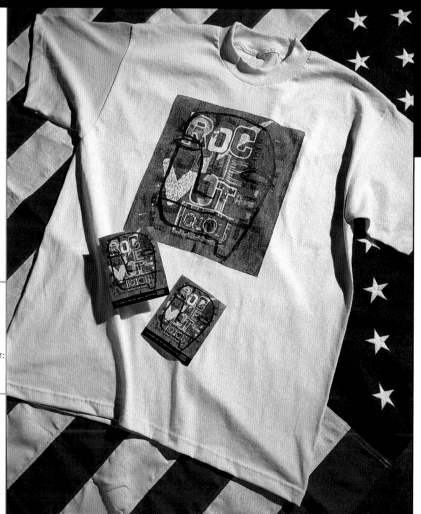

ROCK THE VOTE/T-SHIRT

art director: Carlos Segura;
designers: Kirk Richard Smith,
Carlos Segura; design studio:
Firehouse 101 Art + Design; client:
WKQX (Q-101, Chicago); illustrator:
Kirk Richard Smith; typefaces:
hand calligraphy, found type
The found type is from 1940s fruit
labels.

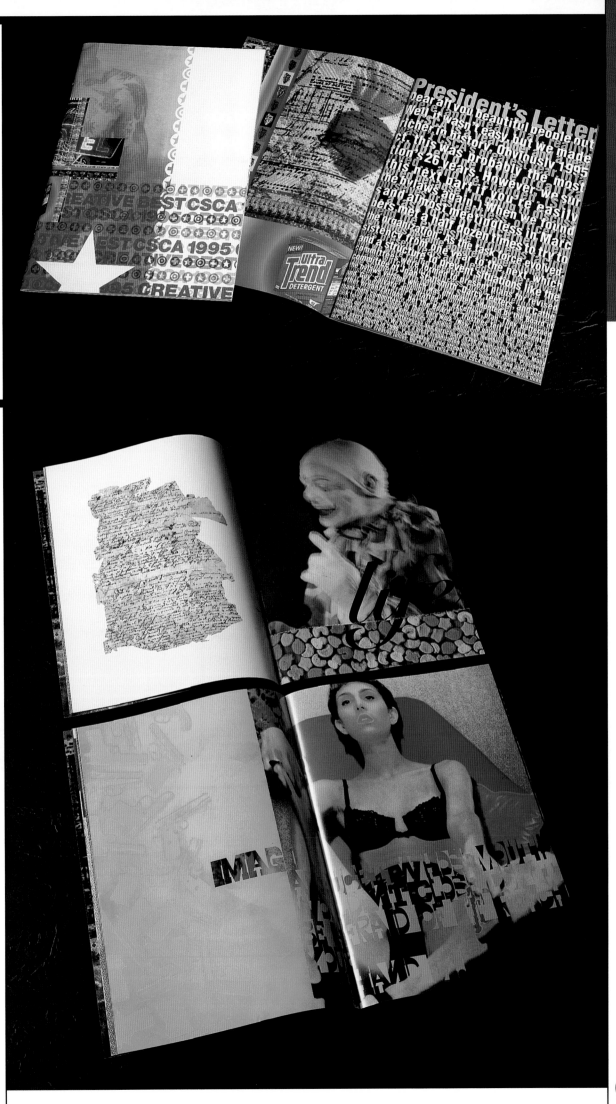

COLUMBUS SOCIETY OF
COMMUNICATING ARTS,
CREATIVE BEST/CATALOG

art director: Kirk Richard Smith;
designers: Kirk Richard Smith, Brad
Egnor; design studio: Firehouse 101
Art + Design; client: Columbus
Society of Communicating Arts
(CSCA); photographers: Chas Krider,
Will Shively, Stephen Webster; illus-
trators: Keith Novicki, Marcelle
Gilkerson, Michiko Stehrenberger;
typefaces: Helvetica Bold (cover
spread); Helvetica Bold Condensed
(president's letter); Snell
Roundhand, found calligraphy,
Yurnacular ("imagine")

Alexander Gelman, an internationally recognized art director and graphic designer, is a recipient of many awards from the New York Art Directors Club, *Communication Arts*, AIGA, 100 Show, *I.D. Annual Design Review*, and numerous international poster biennials. Gelman's work is in the permanent collections of the Smithsonian Institution and the Museum of Modern Art in New York. His 1998 one-man gallery show in Tokyo, "Subtraction," was featured on Japanese national television. Gelman founded Design Machine Co. in 1997; projects include corporate and brand identity, ad campaigns, packaging, and Web and type design. Since 1996, he has taught at the School of Visual Arts and Parsons School of Design. Gelman also publishes and art directs *Obscure Objects*, an experimental design journal.

Alexander Gelman

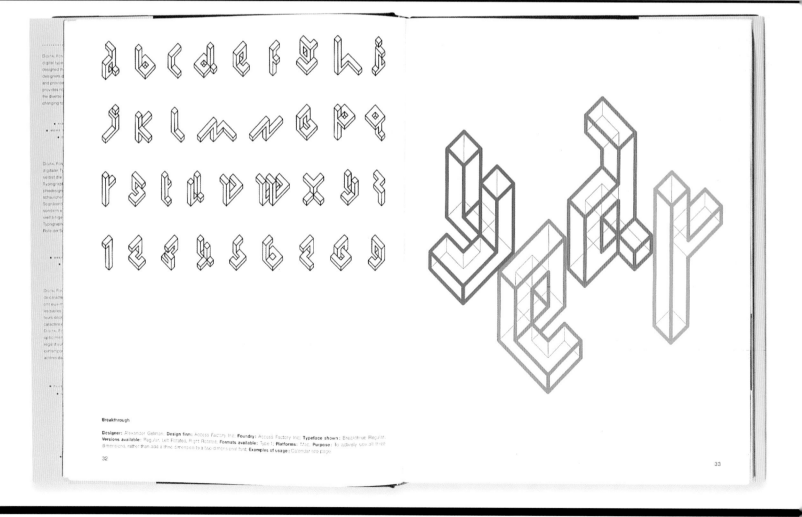

Breakthrough

Designer: Alexander Gelman. **Design firm:** Access Factory Inc. **Foundry:** Access Factory Inc. **Typeface shown:** Breakthrough Regular. **Versions available:** Regular, Left Rotated, Right Rotated. **Formats available:** Type 1. **Platforms:** Mac. **Purpose:** To actively use all three dimensions, rather than add a third dimension to a two-dimensional font. **Examples of usage:** Calendar, title page.

32

33

designer: Alexander Gelman; design studio: Design Machine Co.; client: Design Machine Co.

CHORD/LOGO

designer: Alexander Gelman; design
studio: Design Machine Co.; client:
Chord; typeface: custom

L2/LOGO

designer: Alexander Gelman; design
studio: Design Machine Co.; client: L2;
typeface: Akzidenz Grotesk

EQ8/LOGO

designer/art director: Alexander Gelman;
design studio: Design Machine Co.; client:
EQ8; typefaces: Helvetica Black

JANOU PAKTER MAGAZINE AD CAMPAIGN/AD

designer: Alexander Gelman; design studio: Design
Machine Co.; client: Janou Pakter, Inc.; typefaces:
Akzidenz Grotesk, DIN Mono, Univers (large letters)

"WALLS OF THE
CITY"/POSTER

designer/art director:
Alexander Gelman; design
studio: Design Machine
Co.; client: Mika Press;
typeface: unknown
Russian font

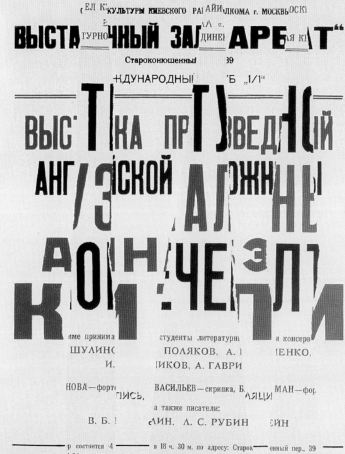

Steven R. Gilmore

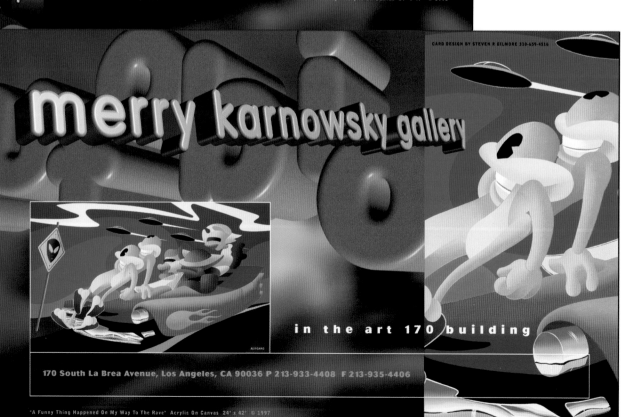

ANTHONY AUSGANG,
"AUTOBIOPSY"/INVITATION
art director/designer: Steven R.
Gilmore; design studio: SRG Design;
client: Merry Karnowsky Gallery;
illustrator/photographer: Anthony
Ausgang; typefaces: Cosmos Extra
Bold, VAG Rounded, Bell Gothic
"Autobiopsy" and "Merry
Karnowsky" were created by
Gilmore.

Steven R. Gilmore is a self-taught artist with no formal training. A background as a DJ at a local Vancouver nightclub led to his first record-sleeve design for a local band in 1979. Since that time he has designed more than two hundred sleeves for record labels. He has also created several corporate identities and promotional items for companies including 20th Century Fox, Coca-Cola, Industrial Light and Magic, Miramax Films, New Line Cinema, Nike and Xerox, as well as promotional material for fashion retail outlets and dance companies. Currently based in Los Angeles, he plans to move in the year 2000 to New York, where he will continue his career in the graphic and fine arts.

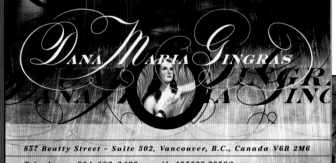

DANA MARIA GINGRAS/BUSINESS CARD
art director/designer: Steven R. Gilmore;
design studio: SRG Design; client: Dana
Maria Gingras; typefaces: Century Bold,
Engravers Bold, custom designed script

DRUM 'N' BASS, *CONSTRUCTION KITS*/CD SET
art director/designer: Steven R. Gilmore; design studio: SRG Design; client:
East-West Communications; typefaces: Bell Gothic, Timbre Alternative
Gilmore designed the large background type for "drum 'n' bass."

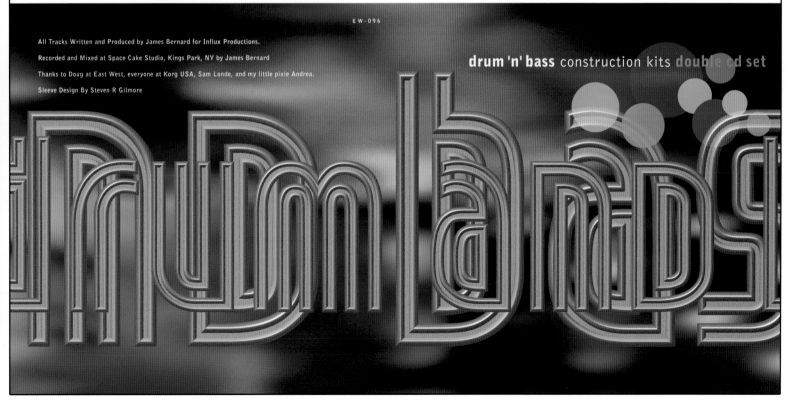

THE HOLY BODY TATTOO, "OUR BRIEF ETERNITY"/POSTER

art director/designer: Steven R. Gilmore; design studio: SRG Design; client: The Holy Body Tattoo; typefaces: Helvetica Rounded, Japanese type (special ordered)

Gilmore designed the main title font by digitally manipulating Helvetica Rounded in Adobe Dimensions and Adobe Photoshop.

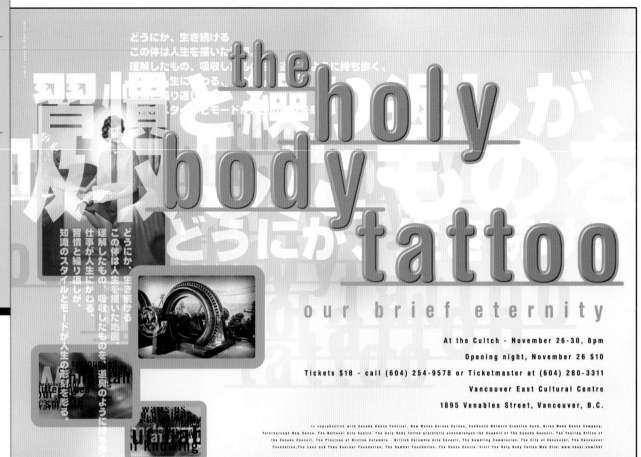

どうにか、生き続ける
この体は人生を描いた
理解したもの、吸収したもの、生に持ち歩く、

the holy body tattoo

our brief eternity

At the Cultch - November 26-30, 8pm
Opening night, November 26 $10
Tickets $18 - call (604) 254-9578 or Ticketmaster at (604) 280-3311
Vancouver East Cultural Centre
1895 Venables Street, Vancouver, B.C.

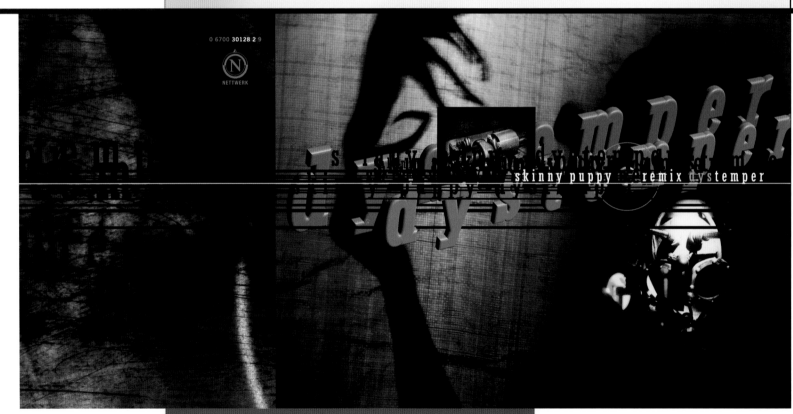

SKINNY PUPPY, *DYSTEMPER*/CD COVER

art director/designer: Steven R. Gilmore; design studio: SRG Design; client: Nettwerk Records; photographers: Jessika White (main photography), Anthony Artiaga (texture photography), Steven R. Gilmore (inset photography); typefaces: Rockwell Condensed, Bell Gothic

Gilmore manipulated Rockwell Condensed in Macromedia Extreme 3D and Adobe Photoshop to create the font used for "dystemper."

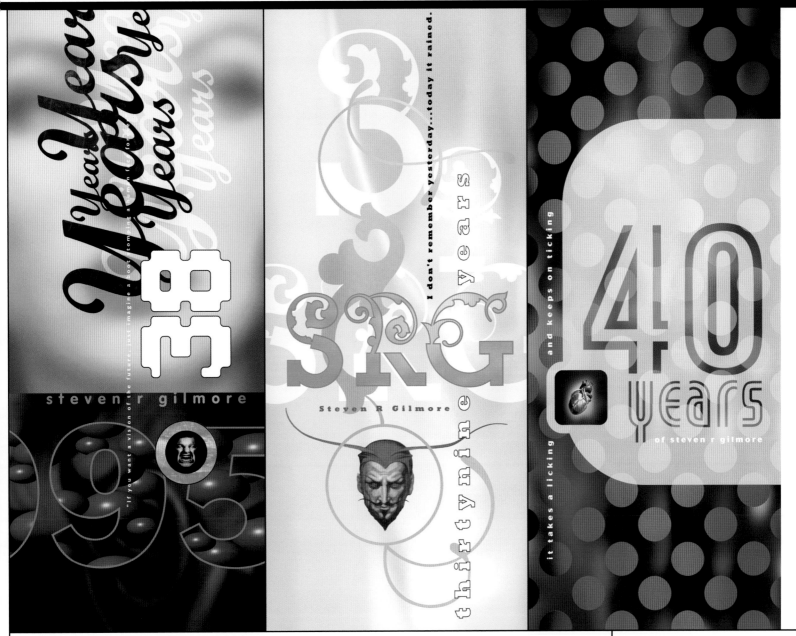

STEVEN R. GILMORE BIRTHDAY PARTIES 1995, 1996, 1997/INVITATIONS
art director/designer: Steven R. Gilmore; design studio: SRG Design; client: self;
typefaces: Cosmos Extra Bold, VAG Rounded, Gill Sans, Mono Script Bold (1995);
Rockwell Extra Bold (1996); Cosmos Extra Bold, Timbre Alternative (1997)
The numerals "38" and "39" were custom designed by Gilmore, as were the initials
"SRG."

In 1996 Kyle Cooper helped found Imaginary Forces, which was the result of a transfer of ownership of R/Greenberg Associates/LA. Cooper has directed live-action sequences for feature films, broadcast projects and commercials. His work has received much recognition, including a British D&AD Gold Award and two Silver Awards, and a 1998 Emmy nomination for the title sequence for TNT's *The George Wallace Story*.

A FILM BY David Fincher

Imaginary Forces

1

2

SEVEN/FILM
director: Kyle Cooper;
designers: Kyle
Cooper, Jenny
Shainin; clients: New
Line Productions Inc.,
David Fincher ; pho-
tos: Peter Sorel;
typefaces: hand let-
tering, Helvetica

Gwyneth Paltrow

3

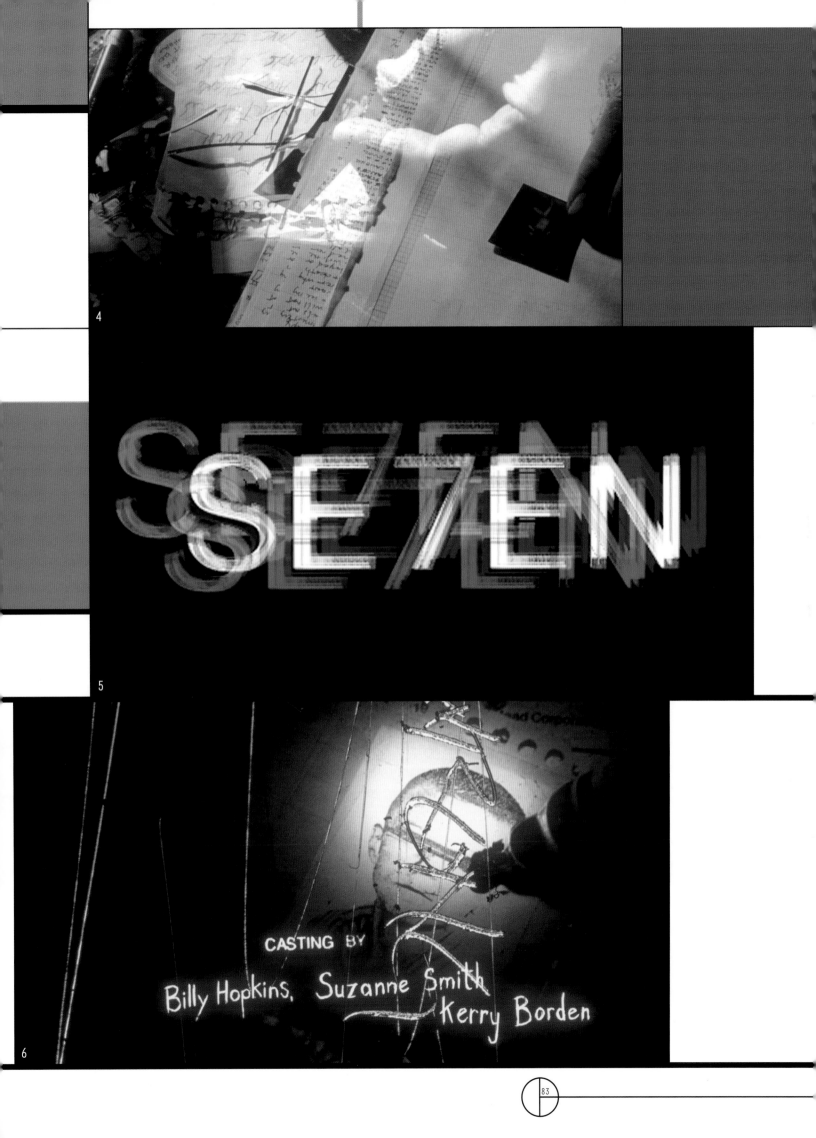

Michael Ian Kaye is the creative director at Little, Brown and Company. Formerly the art director of Farrar Straus & Giroux and an associate art director at Penguin USA, he has designed many books and many more book jackets, working with clients such as The Dial Press, Ecco Press, HarperCollins, Houghton Mifflin, Alfred A. Knopf, W.W. Norton, Random House, Simon & Schuster and Charles Scribner's Sons. Kaye has also designed issues of *U&lc* for the International Typeface Corporation and *Faces on the Edge, Type in the Digital Age* by Steven Heller and Anne Fink. He is currently art directing the *AIGA Journal of Graphic Design*. Kaye's work has won numerous awards and has been exhibited at Cooper-Hewitt, National Design Museum.

Michael Ian Kaye

PLANET OF THE BLIND/BOOK JACKET

designer/art director: Michael Ian Kaye; client: The Dial Press; typeface: ITC Century

Large-print children's books and academic "easy reader" editions for the visually impaired were the basis for this design, since the book is a memoir about growing up legally blind.

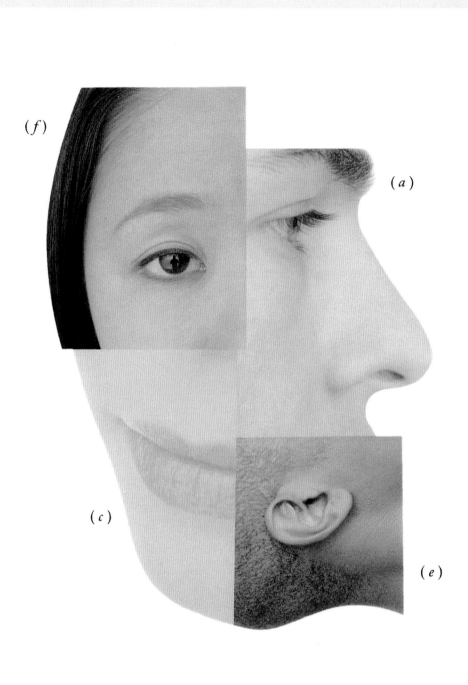

(f)

(a)

(c)

(e)

Daniel McNeill **The Face**

THE FACE/BOOK JACKET
designer/art director:
Michael Ian Kaye; client:
Little, Brown; photograph-
er: Ilan Rubin; typefaces:
Akzidenz Grotesk Bold (title
and author), Adobe Caslon
(letters)
This design is a modern
interpretation of nine-
teenth-century reference
books of botanical and
zoological prints.

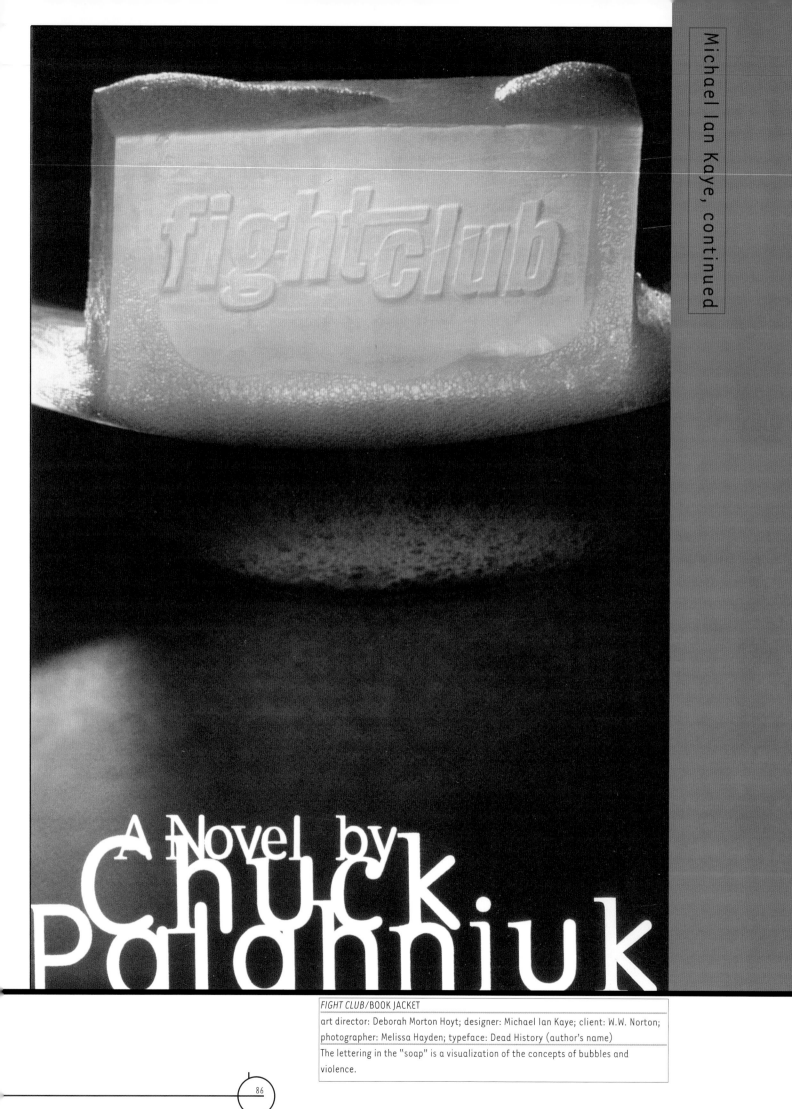

fight club

A Novel by
Chuck
Palahniuk

FIGHT CLUB/BOOK JACKET
art director: Deborah Morton Hoyt; designer: Michael Ian Kaye; client: W.W. Norton;
photographer: Melissa Hayden; typeface: Dead History (author's name)
The lettering in the "soap" is a visualization of the concepts of bubbles and
violence.

LUCK/BOOK JACKET

designer/art director: Michael Ian Kaye; client: Farrar Straus & Giroux; photograph-
er: Melissa Hayden; typefaces: Trade Gothic No. 20 Bold Condensed (title), OCR-B
(background and author's name)

The OCR-B font was used to convey the idea of computer-generated randomness.

LUCK

BILL FLANAGAN

U2

2

AT THE END
OF THE WORLD

U2: AT THE END OF THE WORLD/BOOK JACKET

art director: Jerry Counihan; designer: Michael Ian
Kaye; client: Delacorte Press; photographer: Anton
Corbijn; typefaces: hand lettering ("U2"),
M. Grotesque Black

The *U* and *2* are combined to create an eye icon.

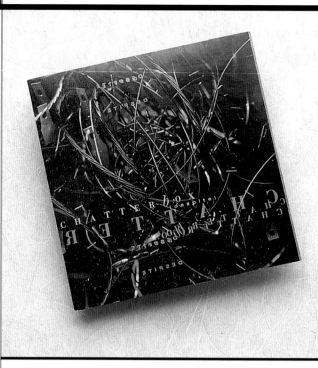

CHATTERBOX,
DESPITE/CD PACKAGE
designer/art director:
Thomas Wolfe; design
studio: Kerosene Halo;
client: Tooth & Nail
Records; photographer:
Kerosene Halo; type-
faces: Bodoni, Univers
The two classic type-
faces Bodoni and
Univers were layered
and flipped to create a
jumbled pattern that
complemented the
rough scan of the cover
image.

Kerosene Halo, a full-service visual communications firm, was formed by Chicago-based designers Greg Sylvester and Thomas Wolfe in 1996. They are best known for their innovative approach to music packaging design. Sylvester began his work in music packaging and publication design at Columbia College, where he earned his degree in graphic design. Wolfe, whose education is in fine arts, served as an art director for several independent record labels before starting his own freelance career. Kerosene Halo's portfolio features more than two hundred album projects—ranging from work for independent musicians to a collaborative effort on Madonna's *Ray of Light* campaign.

Kerosene Halo

KEROSENE HALO
IDENTITY/POSTCARD
designers/art directors: Greg
Sylvester, Thomas Wolfe;
design studio: Kerosene Halo;
client: self; typefaces: Stenso
Quick Transfer (collage),
Eidetic Serif (all secondary
typography)
This postcard, which was
designed to promote Kerosene
Halo's new Web site, uses a
chaotic collage of type to
illustrate the mass of informa-
tion available on the Internet.
Press-on type was chosen to
reflect the firm's traditional
background in print work. The
Web address, while centered
within the technological mess,
is subtly obscured, conveying
the message that this is a
"boutique firm."
Eidetic Serif was designed by
PsyOps.

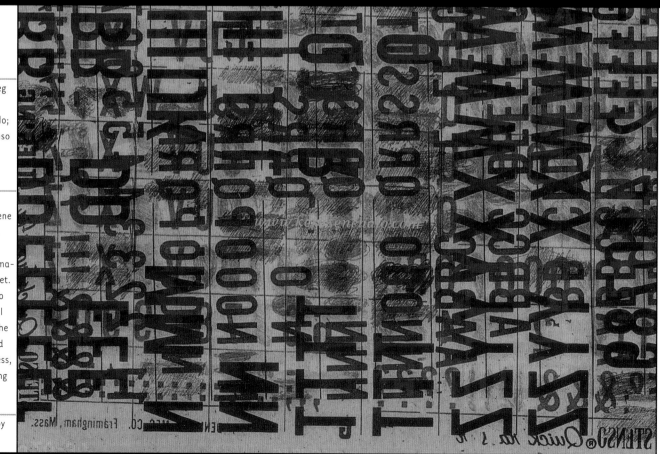

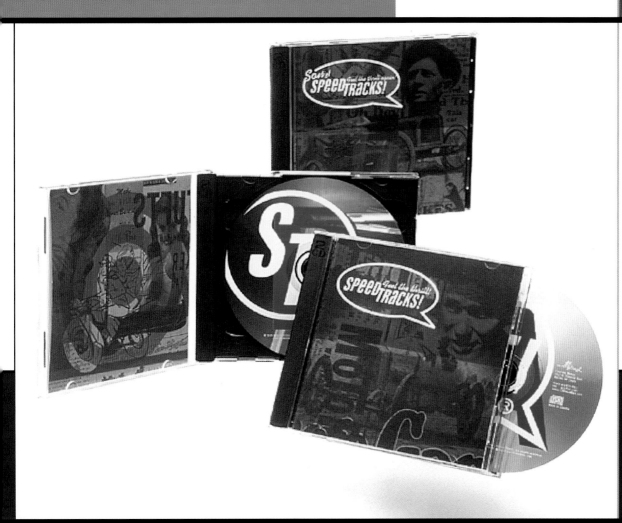

SPEEDTRACKS AND SON OF SPEED-
TRACKS/CD SETS
art directors: Greg Sylvester, Thomas
Wolfe; designer: Thomas Wolfe; design
studio: Kerosene Halo; client: AvDeli;
collage: Kerosene Halo; typefaces:
SpeedTraxs (modified by Kerosene
Halo; logotype), Kaufmann (tag line)
SpeedTraxs is an all-capitals version
of Univers Extra Condensed that was
modified so that several standard
lowercase letters stretch vertically to
capital height. The logo was inspired
by the "bubble" type from 1950s
comics and advertisements.

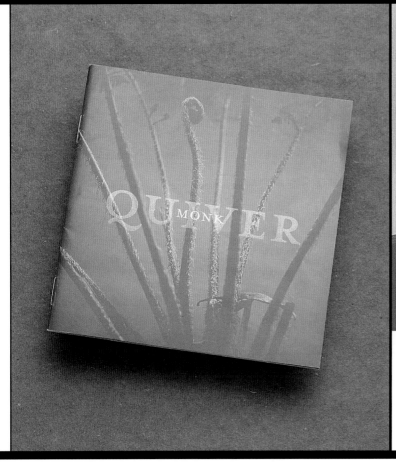

MONK, QUIVER/CD COVERS
designer/art director: Greg Sylvester; design studio: Kerosene Halo; client: Ether Records;
photographer: Michael Wilson; typeface: Mrs. Eaves (designed by Zuzana Licko)
The classical tone of this piece echoes the quiet nature of the music through the delicacy
of Mrs. Eaves. The title was overprinted as a clear foil stamp so that it is visible only when
the package is held at a certain angle.

As senior designer at PolyGram Records, Michael A. Klotz scored with his logo designs and music packaging for such performance legends as the Allman Brothers Band; the Mighty, Mighty Bosstones; and the Meat Puppets. After forming Klotz Graphix in 1995 and locating on Manhattan's Upper East Side, Klotz expanded his talents to encompass advertising and publishing and continues to produce packaging and promotion in the entertainment industry. Presently on special assignment, Klotz is engaged in creating cutting-edge designs for Arista Records and their family of record labels.

Michael A. Klotz

YOU KNOW YOU GOT SOUL/
CD SLEEVE

designer/art director:
Michael A. Klotz; design
studio: Klotz Graphix; client:
Arista Records; illustrator:
Michael A. Klotz; typefaces:
Future Kill, Framed
As Sheri Lee, Senior Art
Director at Arista Records,
put it, "Provided with corny
copy, this could have been
an equally corny solution.
Mike gave the R&B depart-
ment a little soul with a
futuristic flair. Approved, no
problem."

CHARLIE PARKER/
CD COVER

designer/art director:
Michael A. Klotz; design
studio: Klotz Graphix;
client: Verve Records;
illustrator: Michael A.
Klotz; typefaces: hand
lettering

ANIMAL BAG, *HELLO COSMO*/CD COVER
designer/art director: Michael A. Klotz;
design studio: Klotz Graphix; client:
Mercury Records; illustrator: Michael A.
Klotz; typefaces: hand lettering

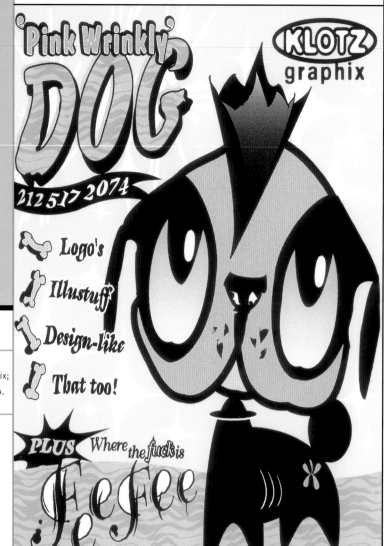

"PINK WRINKLY DOG"/SELF-
PROMOTION
designer/art director: Michael A.
Klotz; design studio: Klotz Graphix;
client: self; illustrator: Michael A.
Klotz; typeface: Finch 17
Klotz explained: "Fishin' with
spam...never did get a call from
this one."

SURGE SODA/LOGO
designer/art director: Michael A.
Klotz; design studio: Klotz Graphix;
client: Nick and Paul the Brand
Agency; illustrator: Michael A.
Klotz; typefaces: custom
"Surge Soda," says Kurt Houser,
Vice President Design Director of
Nick and Paul, "is about a rush of
energy. This approach addresses
the aspect of pumping up the
volume of that energy. It's the
unbridled energy rush machine!"

CMJ 98/POSTER
designer/art director:
Michael A. Klotz; design
studio: Klotz Graphix; client:
CMJ; illustrator: Michael A.
Klotz; typefaces: found type
Old circus type inspired this
poster, which was for a music
and film festival. Klotz
describes it as "Classic
College Indie Alterna-Rock
Poster Art."

When writers create from the heart,
millions feel it in exactly the same place.

Thank you for naming us this year's #1 Record Label
and #1 R&B Label, and congratulations to Usher, Jermaine Dupri and
all of 1998's American Songwriter Award winners.

ARISTA

Frank Kozik was born in Madrid, Spain, and moved to the U.S. as a teenager. Credited with single-handedly reviving the "lost" art of the concert poster (pioneered by 1960s psychedelic rock posters), Kozik is a self-taught technical wizard who has raised the craft of silkscreen printing to new heights. Kozik's career grew largely out of his enthusiasm for the burgeoning underground alternative rock scene in Austin, Texas, in the mid 1980s. He has produced posters and artwork in recent years for such bands as Nirvana, Pearl Jam, the Red Hot Chili Peppers and Sonic Youth. Kozik's works were displayed at the opening of the Rock and Roll Hall of Fame, and his designs have also been used by mainstream organizations such as Nike, BASF, Slim Jim and MTV.

THE HEADS, *THE TIME IS NOW!*/CD COVER
designer/art director: Frank Kozik; client: Man's Ruin Records; illustrator: Frank Kozik; typeface: Bellbottom

ELECTRIC FRANKENSTEIN/HOOKERS/CD COVER
designer/art director: Frank Kozik; client: Man's Ruin Records; illustrator: Frank Kozik; typefaces: House Industries flyer font ("Listen Up, Baby!"), hand lettering ("Electric Frankenstein"), Concrete ("Hookers")

7 YEAR BITCH, *MISS UNDERSTOOD*/45 SLEEVE
designer/art director: Frank Kozik; client: Man's Ruin Records; illustrator: Frank Kozik; typefaces: Jazz Club, ITC Gorilla
Kozik cites "circus stuff" as the source for this design.

TREE, *VOTE WITH A BULLET*/45 SLEEVE
designer/art director: Frank Kozik; client: Man's Ruin Records; illustrator: Frank Kozik; typefaces: Publicity Gothic, Bernhard Antique

Patricia Lie transferred from the University of California—Berkeley to Parsons School of Design, New York City, in 1984 in order to learn about applied arts (translation: how to make a living). She then worked at the Palladium (*the* New York nightclub of the 1980s) cranking out invites and posters during the nightlife heyday. Later she worked at Relativity Records and PolyGram before transferring to Verve in 1995. In 1996 she was promoted to creative director, and she currently lives in New York City with her husband and their three-legged cat.

Patricia Lie

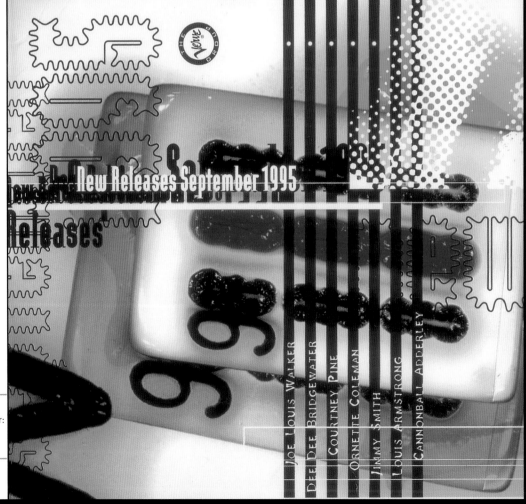

HANK JONES, *FAVORS*/CD COVER
designer/art director: Patricia Lie; client: Verve Records; illustrator: Istvan Banyai; typeface: Variex

SEPTEMBER 1995 NEW RELEASES/
CD SLEEVE
designer/art director: Patricia Lie; client: Verve Records; photographer: Patricia Lie; typefaces: Modula, found type
The found type came from mahjongg tiles.

New Releases September 1995

JOE LOUIS WALKER
DEE DEE BRIDGEWATER
COURTNEY PINE
ORNETTE COLEMAN
JIMMY SMITH
LOUIS ARMSTRONG
CANNONBALL ADDERLEY

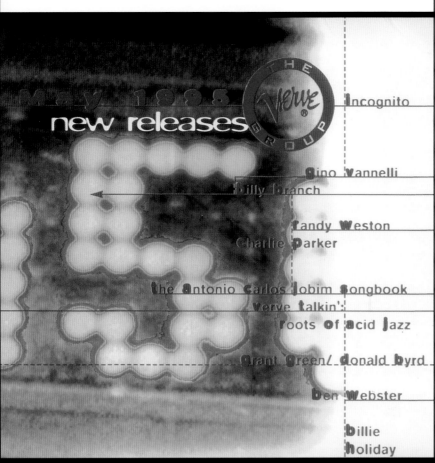

Incognito

Gino Vannelli

billy branch

randy weston

Charlie Parker

the Antonio Carlos Jobim Songbook

Verve talkin':

roots of acid jazz

Grant Green/ donald byrd

ben Webster

billie holiday

MAY 1995 NEW RELEASES/CD SLEEVE
designer/art director: Patricia Lie; client: Verve Records; photographer: Patricia Lie; typefaces: found numbers

The found numbers are from bus lights.

HERBIE HANCOCK, *THE NEW STANDARD*/CD COVER
designer/art director: Patricia Lie; client: Verve Records; photographer: James R. Minchin III; typeface: Helvetica Condensed

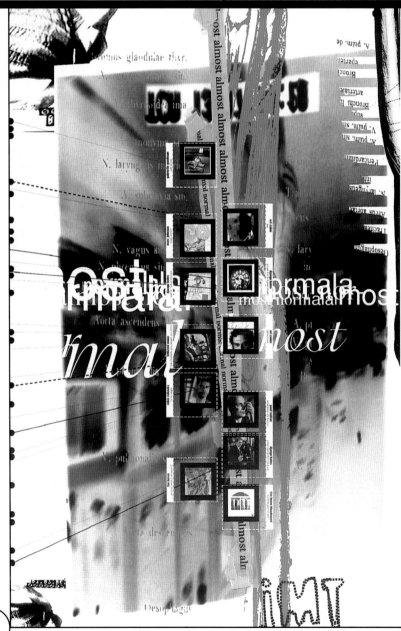

JOHN SCOFIELD,
A GO-GO/CD COVER
designer/art director:
Patricia Lie; client:
Verve Records;
photographer: Marc
Joseph; typefaces:
Bauhaus, Pump

JMT, *ALMOST NORMAL*/POSTER
designer/art director: Patricia Lie; client: Verve/JMT
Records; photographer: Marc Friedlander; typefaces:
Helvetica, Times, found type

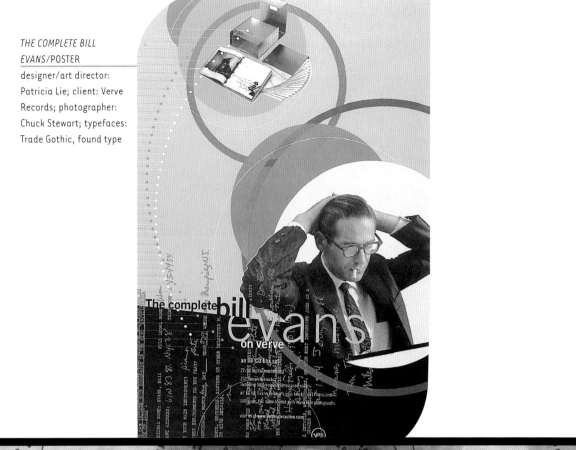

THE COMPLETE BILL EVANS/POSTER
designer/art director: Patricia Lie; client: Verve Records; photographer: Chuck Stewart; typefaces: Trade Gothic, found type

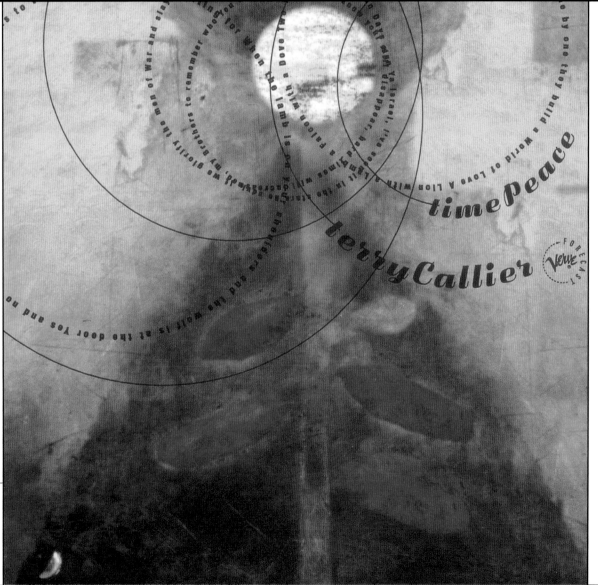

TERRY CALLIER, *TIME PEACE*/CD COVER
designer/art director: Patricia Lie; client: Verve Records; illustrator: Michael Morgenstern; typefaces: Fluidum, Trade Gothic Condensed

ALISON
WILDING

ALISON WILDING EXHIBITION/POSTER
designer/art director: Peter Maybury;
client: Douglas Hyde Gallery (Dublin);
typeface: DIN Schriften Mittelschrift

27 APRIL — 31
MAY 1996

ECHO

STREET ART, "OUTDOOR
IMAGES"/BROCHURE
designer/art director:
Peter Maybury; client:
Temple Bar Properties
(Dublin); photographer:
Peter Maybury; type-
face: Citizen

DHg THE DOUGLAS HYDE GALLERY

OPENING HOURS : THE DOUGLAS HYDE
MONDAY – FRIDAY , 11 – 6 GALLERY
THURSDAY , 11 – 7 TRINITY COLLEGE, NASSAU
SATURDAY , 11 – 4.45 STREET,
 DUBLIN 2, IRELAND

Peter Maybury

tem·po·rar|y (tem´ pə rer´ē) adj. [[L. temporarius < tempus, time : see temper]]
lasting, enjoyed, used, etc. for a time only ; not permanent — n. an employee hired for temporary
service, esp. an office worker — tem·po·rar|i·ly (tem´ pə rer´ə lē] adv. — tem´ po rari·ness n.
public (pub´lik) adj. [[ME< L publicus : altered (prob. infl. by pubes, adult) < poplicus,
contr. of populicus, public<populus, the PEOPLE]] 1 of, belonging to, or concerning the people as a
whole ; of or by the community at large [the public welfare, a public outcry] 2 for the use or
benefit of all ; esp. supported by government funds [a public park] 3 as regards community, rather
than private, affairs 4 acting in an official capacity on behalf of the people as a whole [a public
prosecutor] 5 known by, or open to the knowledge of, all or most people [to make information public,
a public figure]
art' (ärt) n. [[ME < OFr arte < L ars (gen. artis), art < IE base*ar – joint]]
1 human ability to make things ; creativity of men as distinguished from the world of nature 2 skill ;
craftsmanship 3 any specific skill or its application [the art of making a friend] 4 any craft, trade,
profession, or its principles [the cobbler's art, the physician's art] 5 creative work or its principles ;
a making or doing of things that display form, beauty and unusual perception : art includes painting,
sculpture, architecture, music, literature, drama, the dance, etc. : see also fine art 6 any branch of
creative work, esp. painting, drawing, or work in any other graphic or plastic medium 7 products of
creative work ; paintings, statues, etc. 8 pictorial and decorative material accompanying the text in
a newspaper, magazine or advertising layout 9 a) [Archaic] learning b) a branch of learning c [pl.]
the liberal arts (literature, music, philosophy, etc.) as distinguished from the sciences 10 artful
behaviour ; cunning 11 sly or cunning trick ; wile – usually used in pl.

temple bar street '98

A R T

sponsored by

TEMPLE BAR

TEMPLE BAR STREET ART '98

Temple Bar Properties has commissioned 5 artists
to produce 4 temporary works over 7 months in
Temple Bar, continuing our street art project of
enhancing the relationship between the public and
the artist. From Paddy Jolley and Laurent Mellet's
playful homage to Ireland's agricultural rather
than militaristic history to Maud Cotter's colourful
interplay with passers-by on Curved Street,
these pieces recognise the traditional perceptions
of public art and try to subvert these expectations.
Situated in the main pedestrian areas of
Temple Bar–Temple Bar Square and Curved Street –
Street A R T '98-99 hopes to surprise and
stimulate visitors to this cultural quarter.

schedule :			
	laurent mellet & paddy jolley	CENOTAPH (temple bar square)	tues 8 sept – sun 1 nov 1998
	gary somers	METAMORPHOSIS (temple bar square)	mon 2 nov – sun 13 dec 1998
	maud cotter	SHADOW (curved street)	mon 14 dec – wed 27 jan 1999
UPCOMING :			
	stephen gunning	URBAN SANCTUARY (temple bar square)	thurs 28 jan – tues 16 mar 1999

TRIBUNE INTERACTIVE/NEWSPAPER SUPPLEMENT
designer/art director: Peter Maybury; client: *The Sunday Tribune* (Dublin); photographer: Peter Maybury; typefaces: Synchro (heads and folios), Grotesque

Peter Maybury was born in Dublin in 1969. After graduating from Dun Laoghaire College of Art & Design in Dublin and earning an M.A. from Central Saint Martins, London, he set up a design studio in Dublin. He lectures in design and produces limited edition books and prints, photography, music, film and video projects. In 1998 his work was exhibited at the "90_Degrés" gallery in Bordeaux, and he was selected for *I.D. Magazine*'s international "I.D. Forty." His work has been featured in *Blueprint* and *Emigré* magazines.

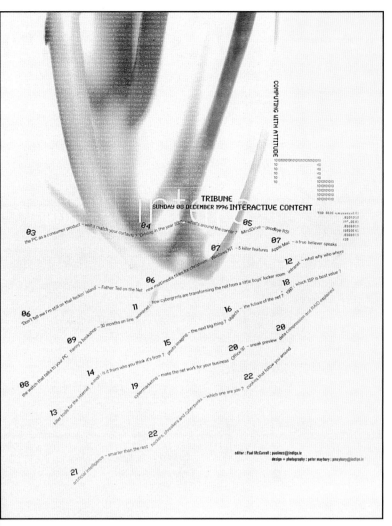

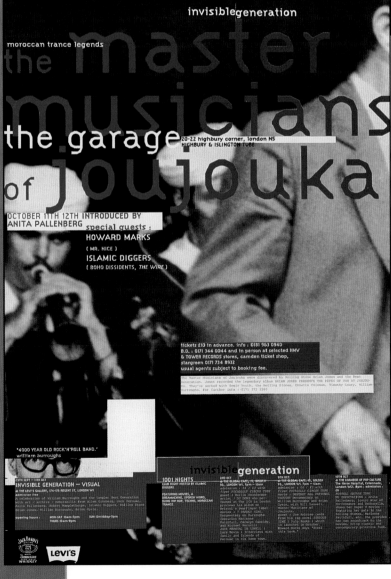

"MASTER MUSICIANS OF JOUJOUKA"/POSTER
designer/art director: Peter Maybury; client: Delinquente (London); photographer: unknown; typeface: Citizen

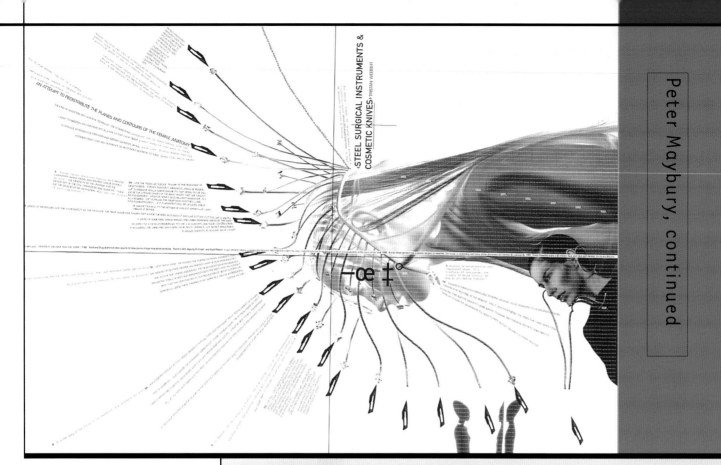

STEEL SURGICAL INSTRUMENTS & COSMETIC KNIVES TRISTAN WEBBER

"ENHANCE 57:19,"
ENHANCED MAGAZINE/
MAGAZINE SPREAD
designer/art director:
Peter Maybury; client:
Temporary Release
(London); photographer: Gavin Fernandez;
typefaces: DIN
Schriften Mittelschrift,
Eurostile, Courier

CODE 4/MAGAZINE
SPREAD
designer/art director:
Peter Maybury; client:
Temporary Release
(Dublin); typeface:
Bell Gothic

BISK/FLYER
designer/art director: Peter Maybury; client: Sub Rosa (Belgium); photographer: Ayako Matsuoka (portrait), Jean François Millet (CD cover inset); typefaces: DIN Schriften Mittelschrift, Helvetica (numbers)

5 "411867"111122"

SR112

5 411867 111122

the japanese futuristic bastard son of techno trip hop

Bisk > Time > SR112

16年 4月18日

Bisk > Time > SR112

Bisk > Time > SR112

sub rosa

po box 808 cm 1000 brussels belgium [info fax : 32 2 736 7974]

peter maybury é

g r a p h i s t e 2

exposition présentée du

90 de g

90 rue notre
33000 bo
tel 5 787
fax : 05 565
e.mail : 90@art_esm

"90_DEGRÉS" EXHIBIT/POSTER
designer/art director: Peter Maybury; client: 90_Degrés (Bordeaux, France); photographer: Peter Maybury; typeface: DIN Schriften Mittelschrift

BUSY GOING CRAZY/CD BOOKLET
designer/art director: Peter Maybury; client: White Lines (London); photographer: Peter Maybury; typeface: Bell Gothic

All songs written and produced by Mike Mason except 5. Heavenly (Mason / Trehy) 1. 2. 3. 4. 6. 7. 8. 10 mixed by Alan Moulder at The Church and Konk studios. Tracks 5. 10 mixed by Mike Mason at Dogray Sounds. Vocals Louise Trehy. Thanks to Alex Mitchell for extra drum programming on 2. 8. 9. Cat. no. LINE 003CD distributed by Vital Distribution. All songs copyright © White Lines (Communications) 1996.

BUSY GOING CRAZY

note : This is a compilation of the first two Busy Going Crazy EPs plus two extra tracks.
Made in England
info : White Lines (Com.) PO Box 9732 London SE5 9ZB.
facsimile tel. no. UK (0) 171 326 4972

Me Company

Me Company is a team of designers, directors, copywriters and thinkers who share a passion for modernity and technology. The work is thought provoking, detailed, entertaining and driven by a desire to speak powerfully to a visually sophisticated audience. Founded twelve years ago by Paul White, the company initially worked exclusively on music industry projects; as the company developed, the client list and type of commission has diversified. The company is developing a portfolio of work which includes advertising, character design, TV, video, film and the Internet.

CARL COX (FACT2)/POSTER
design studio: Me Company; client: React; typeface: DIN
According to Me Company, this design was "inspired by wild excess and loud music. Junkyard typography, crashed techno-gothic."

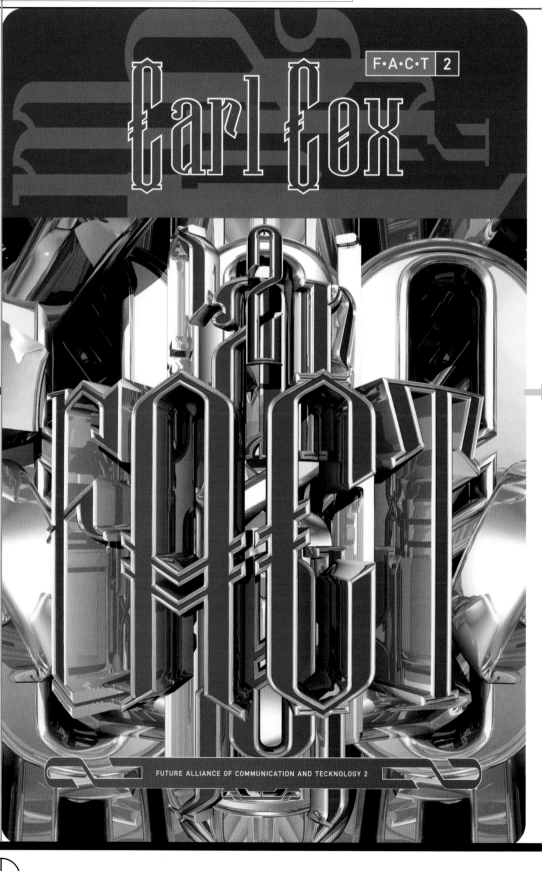

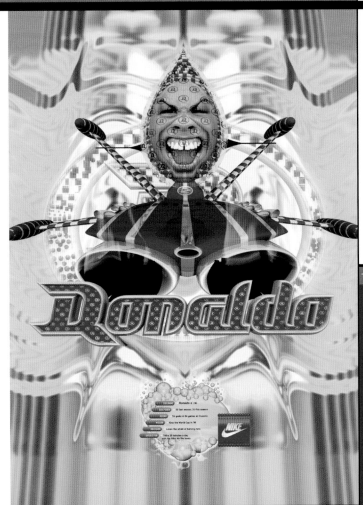

RONALDO/POSTER

design studio: Me Company; client: Wieden &
Kennedy (Nike); typeface: DIN

For this poster, Me Company was "inspired
by the feet of a great man."

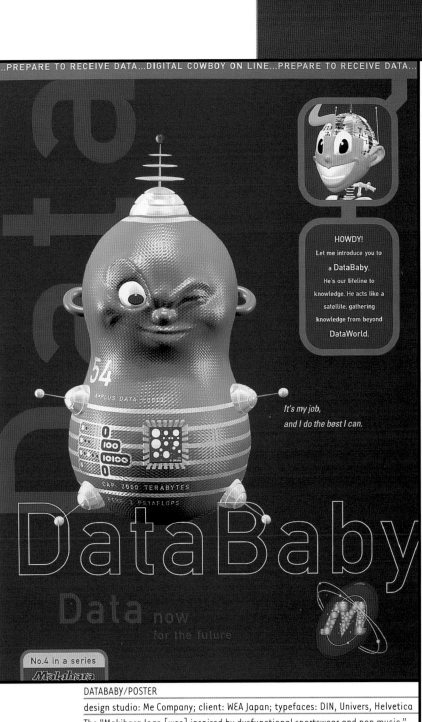

HOWDY!
Let me introduce you to
a DataBaby.
He's our lifeline to
knowledge. He acts like a
satellite, gathering
knowledge from beyond
DataWorld.

It's my job,
and I do the best I can.

DataBaby

Data now
for the future

No.4 in a series
Makihara

DATABABY/POSTER

design studio: Me Company; client: WEA Japan; typefaces: DIN, Univers, Helvetica
The "Makihara logo [was] inspired by dysfunctional sportswear and pop music,"
according to Me Company.

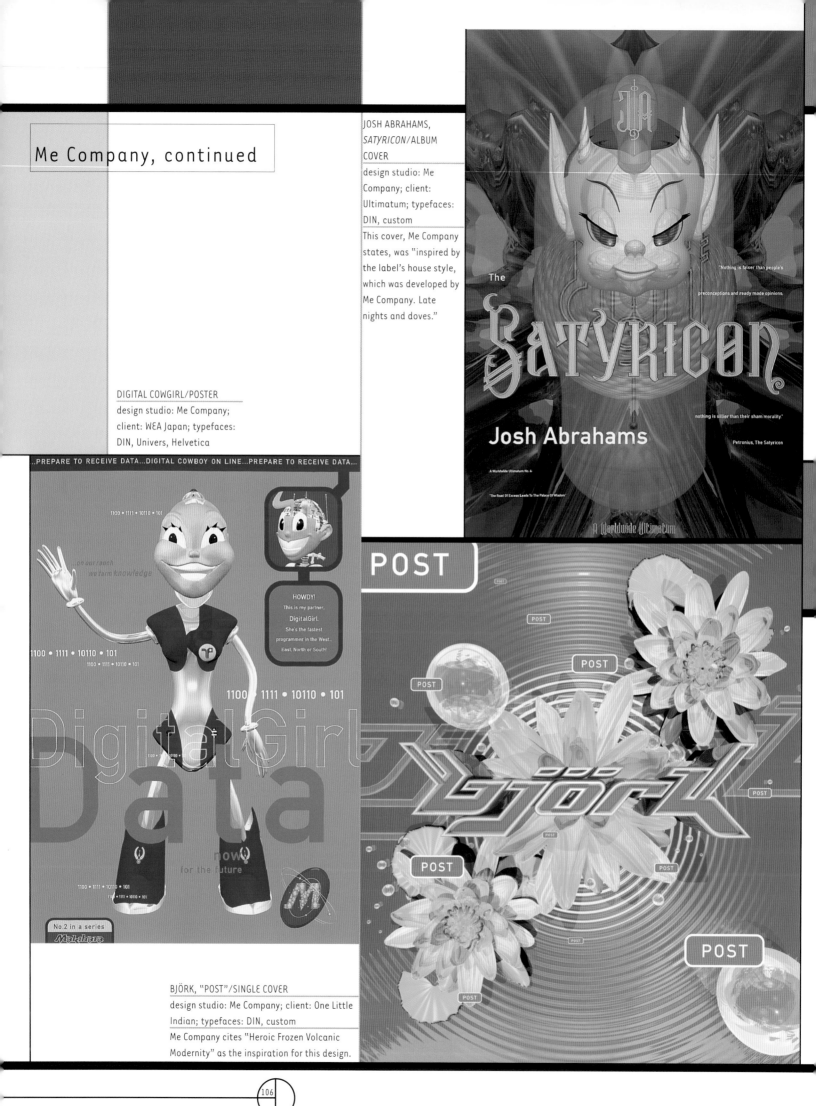

Me Company, continued

DIGITAL COWGIRL/POSTER
design studio: Me Company;
client: WEA Japan; typefaces:
DIN, Univers, Helvetica

JOSH ABRAHAMS,
SATYRICON/ALBUM
COVER
design studio: Me
Company; client:
Ultimatum; typefaces:
DIN, custom
This cover, Me Company
states, was "inspired by
the label's house style,
which was developed by
Me Company. Late
nights and doves."

The

SATYRICON

"Nothing is falser than people's

preconceptions and ready made opinions.

nothing is sillier than their sham morality."

Josh Abrahams

Petronius, The Satyricon

A Worldwide Ultimatum No. 6

"The Road Of Excess Leads To The Palace Of Wisdom"

A Worldwide Ultimatum

...PREPARE TO RECEIVE DATA...DIGITAL COWBOY ON LINE...PREPARE TO RECEIVE DATA...

1100 • 1111 • 10110 • 101

...on our ranch
we farm knowledge

1100 • 1111 • 10110 • 101

1100 • 1111 • 10110 • 101

HOWDY!
This is my partner,
DigitalGirl.
She's the fastest
programmer in the West...
East, North or South!

1100 • 1111 • 10110 • 101

DigitalGirl

1100 • 1111 • 10110 • 101

Data

now!
for the future

1100 • 1111 • 10110 • 101

110 • 1111 10110 • 101

No.2 in a series
Malahara

POST

POST

POST

POST

POST

STÖRZ

POST

POST

POST

POST

POST

BJÖRK, "POST"/SINGLE COVER
design studio: Me Company; client: One Little
Indian; typefaces: DIN, custom
Me Company cites "Heroic Frozen Volcanic
Modernity" as the inspiration for this design.

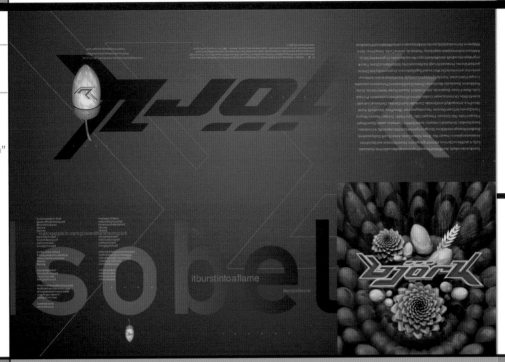

BJÖRK, "ISOBEL"/SINGLE
COVER
design studio: Me Company;
client: One Little Indian;
typefaces: DIN, custom
Me Company credits "big
band explosions and circus
hysterics" and "Big Band
meets Big Top, culture clash"
as their influences.

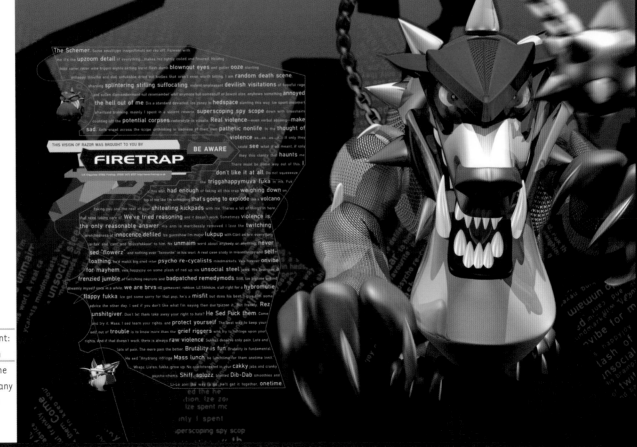

FIRETRAP/DPS AD, POSTER
design studio: Me Company; client:
Firetrap; typefaces: DIN, custom
The logo belongs to the client; the
creator is unknown. As Me Company
put it, the copy was "inspired by
the voices in [the designers']
heads."

MetaDesign, founded by Erik Spiekermann, specializes in integrating brand identity with information architectures, interaction design and implementation systems. Spiekermann's typeface Meta is rapidly becoming one of today's most popular fonts. MetaDesign has grown to be Germany's largest design studio in the last seven years. Spiekermann is also a partner in FontShop, an international franchise of mail-order type libraries for Macs and PCs, with a catalog of over three thousand typefaces; he is also a visiting professor of communication design at Bremen University. Spiekermann has written several books on design and typography, notably *Stop Stealing Sheep* (Adobe Press).

MetaDesign

With the Glasgow 1999 typeface, different character options allow variety when setting headlines.

Most characters have been designed with several variants: under/overscores and ornamented counters.

Here are some of the characters that are available. Information on how to select them can be found in the Typeface User Manual.

The typeface is available on the Resource CD-ROM.

For supplementary text requirements, two secondary typefaces have been chosen to support the Glasgow 1999 typeface:

Adobe Frutiger
Bitstream Caslon

These should be the only other typefaces used.

QuarkXPress templates are available, containing preferred text settings. These can be found on the Resource CD-ROM.

The units specified in these text settings relate to QuarkXPress.

Frutiger Roman has been used as the correspondence typeface for Glasgow 1999 and is suitable for large amounts of text. This sample has been set in Frutiger Roman, 8pt with 11pt leading, 5 units letterspacing and ranged left.

Frutiger Italic has been included to allow for emphasis to be made within text, highlighting names and titles. Frutiger Italic may also be used for captions but not for large amounts of text. This sample has been set in Frutiger Roman Italic, 8pt with 11pt leading, 5 units letterspacing and ranged left.

Frutiger Bold can be used for headings and to give emphasis within text. It may be appropriate to set introductory paragraphs and captions in bold. Frutiger Bold is not suitable for large amounts of text. This sample has been set in 8pt with 11pt leading and 5 units letterspacing.

Frutiger Condensed Roman, can be used for headings and captions. It may also be used in conjunction with Frutiger Condensed Bold to give emphasis within text. Frutiger Condensed Roman is not suitable for large amounts of text. This sample has been set in 8pt with 11pt leading and 7 units letterspacing.

Frutiger Condensed Bold can be used for headings and captions as in these guidelines. It may also be used in conjunction with Frutiger Condensed Roman give emphasis within text. Frutiger Condensed Bold is not suitable for large amounts of text. This sample has been set in 8pt with 11pt leading and 7 units letterspacing.

Bitstream Caslon has been chosen as a text face. In editorial work it is often advisable to use a serif typeface. This sample is set in 8pt with 10pt leading and 4 units letterspacing.

Bitstream Caslon Italic should be used to give emphasis within text, highlighting names and titles. Bitstream Caslon Italic may also be used for captions but not for large amounts of text. This sample has been set in 8pt with 10pt leading and 5 units letterspacing.

Bitstream Caslon Bold can be used for headings and to give emphasis to names and titles within text. It may be appropriate to set introductory paragraphs and captions in bold. Bitstream Caslon Bold is not appropriate for large amounts of text. This sample is set in 8pt with 10pt leading and 5 units letterspacing.

The Glasgow 1999 typeface is a headline typeface, and is not intended to be used as text (it won't work below 15pt).

The typeface is also unable to function if it is letterspaced and the use of hyphenation and justification are important considerations. More information on all these guides can be found in the Typeface User Manual.

It should be made clear that the Glasgow 1999 typeface is for sole use on project work commissioned by Glasgow 1999.

The typeface is provided free for all these requirements. We should warn you that the use of the typeface for any other project is strictly forbidden.

GLASGOW 1999/MANUAL

designer: MetaDesign; client: Glasgow 1999; typefaces: Glasgow 1999, Adobe Frutiger

The identity system for the Glasgow 1999 UK City of Architecture and Design Festival was developed by MetaDesign London.

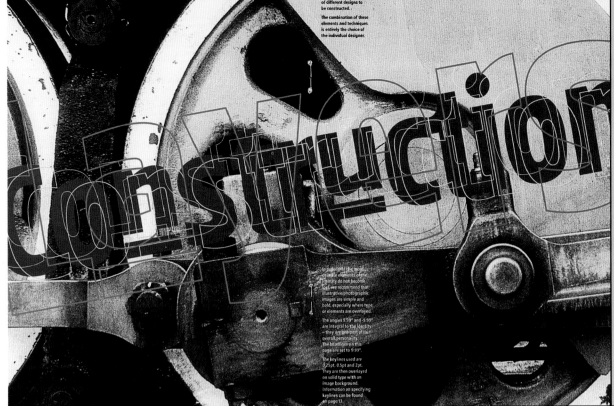

of different designs to
be constructed..

The combination of these
elements and techniques
is entirely the choice of
the individual designer.

To ensure that the most
delicate elements of the
identity do not become
lost we recommend that
illustrative/photographic
images are simple and
bold, especially where type
or elements are overlayed.

The angles 9.59° and -9.59°
are integral to the identity
– they are one part of its
overall personality.
The headlines on this
page are set to 9.99°.

The keylines used are
0.25pt, 0.5pt and 2pt.
They are then overlayed
on solid type with an
image background.
Information on specifying
keylines can be found
on page 13.

GLASGOW 1999/MANUAL

designer: MetaDesign; client:
Glasgow 1999

After winning an international design
competition, MetaDesign was commis-
sioned to provide a unique typeface for
the Glasgow 1999 UK City of Architecture
and Design Festival. The result, Glasgow
1999, was inspired by the 1908 German
face Block. It was refined by Ole
Schafter from a concept created by Erik
Spiekermann.

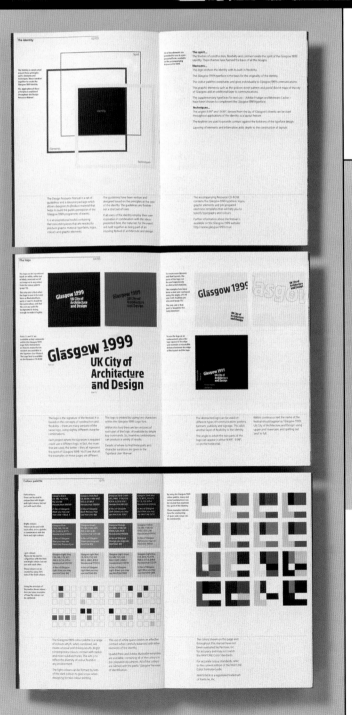

GLASGOW 1999/MANUAL

designer: MetaDesign; client: Glasgow 1999; typefaces:
Glasgow 1999, Adobe Frutiger

The Glasgow 1999 typeface is shown in use in the
resource manual, which has several foldouts.

Sean Mosher-Smith is currently senior art director at RCA Records in New York, where he directs photo shoots and oversees and designs CD packages as well as point-of-purchase material and advertising; he is also co-creative director of slow HEARTH studio, inc., with his wife, Katie. A design and photography studio specializing in design and art for the entertainment industry, slow HEARTH studio's clients include MTV, Viacom, RCA Records, Warner Bros. Records, *Time Magazine*, Condé Nast, Tommy Boy Records, Showtime, Lincoln Center and the Art Directors Club, New York City. Sean and slow HEARTH studio's designs and photography were featured in Steven Heller and Gail Anderson's *Typography Book*.

<div style="writing-mode: vertical">*Sean Mosher-Smith*</div>

THE VERVE PIPE,
VILLAINS/CD COVER
designer/art director:
Sean Mosher-Smith;
client: RCA Records;
photographer: slow
HEARTH studio; type-
face: Degenerate
The designer wanted
"something a little
distressed, like the
band itself."

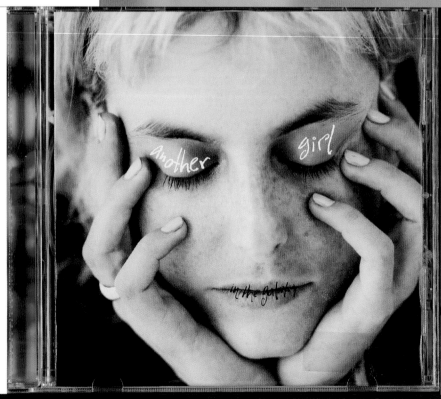

the verve pipe

villains

ANOTHER GIRL, *IN THE GALAXY*/CD COVER
designers/art directors: Sean Mosher-Smith, Kim Biggs; client: RCA Records;
photographer: Cathrine Wessell; artwork: Lynne Kellmen; typeface: hand
lettering (title)

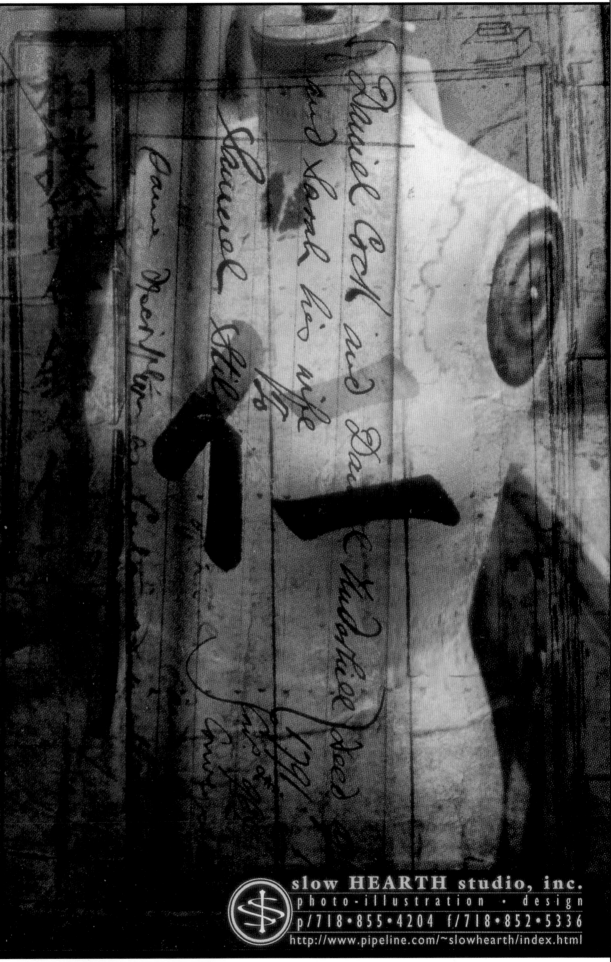

slow HEARTH studio, inc.
photo-illustration · design
p/718·855·4204 f/718·852·5336
http://www.pipeline.com/~slowhearth/index.html

SLOW HEARTH STUDIO SELF-PROMOTION/POSTCARD
art director: slow HEARTH studio; designer: Sean Mosher-Smith; client: self; photographers: Sean and Katie Mosher-Smith; typefaces: Galliard (studio name), Gill Sans, hand lettering (logo)
The type was chosen for its simplicity in order for the image to be the primary focus.

SKOLD/POSTER
designer/art director: Sean Mosher-Smith; client: RCA Records;
photographers: Kate Swan, Jason Beaupré; typeface: Identification

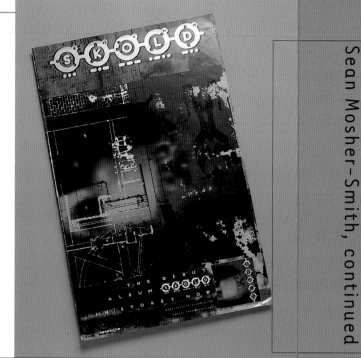

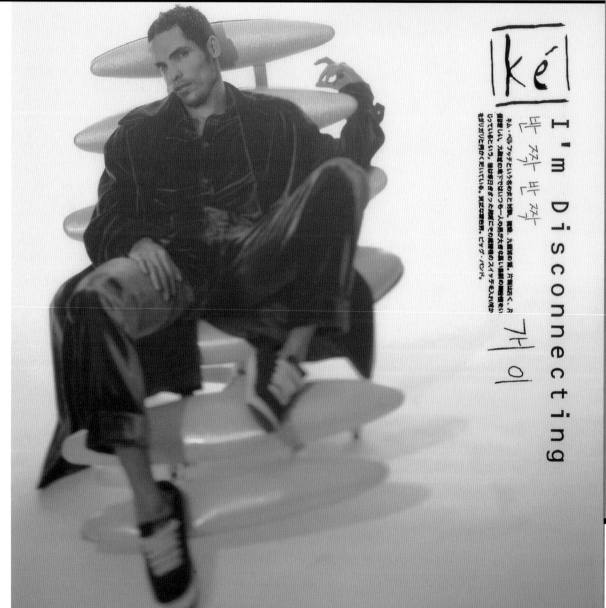

Ké I'm Disconnecting

반짝 반짝

개이

ケ・ペルフッチというものだと読書、映像、九州地の風、片瀬江の見、雲ますとくちだ
音楽い、九州の風アではないつて一人のラのスイチをおい味い言語いてき味言わ
ひっていわむのは、彼の頭家がすっと音いての音響のスイッチもスれの内容
きかびとい色もくあいうにいち、其空はおもと、ピック・バンド、

KÉ, I'M DISCONNECTING/CD
designer/art director: Sean Mosher-Smith; client: RCA Records; photographers:
Kate Swan, Jason Beaupré; typefaces: Roughhouse ("Ké"), OCR-B (title), Korean
hand lettering (by Christine Kim)
The typeface was inspired by Japanese wood stamps and Asian billboard design.

JUNKSTER, *SLIDE*/CD

designer/art director: Sean Mosher-Smith; client: RCA Records; photographer: Katie Mosher-Smith for slow HEARTH studio; typeface: custom ("Junkster")

Sean Mosher-Smith designed the "Junkster" type, which was fabricated and welded in steel by Genice, to give it a hard-edged and cold feeling, like the nightclubs in New York and London.

LA BOUCHE, *SOS*/CD

designer/art director: Sean Mosher-Smith; client: RCA Records; photographer: Davies + Davies; typefaces: Blahaus (title and logo), Trade Gothic (body)

For this design Mosher-Smith took cues from club flyers.

BEHAN JOHNSON/POSTER

designer/art director: Sean Mosher-Smith; client: RCA Records; photographer: David Jensen; photo-illustration: Sean Mosher-Smith; typefaces: Duchamp (album title), Indelible Victorian (type layers and lyrics)

The design is a visualization of the music.

MOVIE AWARDS 1998/VIDEO
designer: Rodger Belknap; art director:
Romy Mann; client: MTV; typeface:
Impact

The type evokes "that 70s feeling."

1

MTV On-Air Design

2

MTV: Music Television is the first 24-hour video music network, launched in 1981. Through its graphic look, VJs, music specials, and documentaries, MTV has become an international institution of pop culture and leading authority on music. MTV's programming includes regular series, specials, and events. The "MTV Movie Awards" has become one of the most entertaining and critically acclaimed award shows. The unconventional and unpredictable show features unusual categories such as Best Action Sequence, Best Villain and Best Kiss, and clever film spoofs.

3

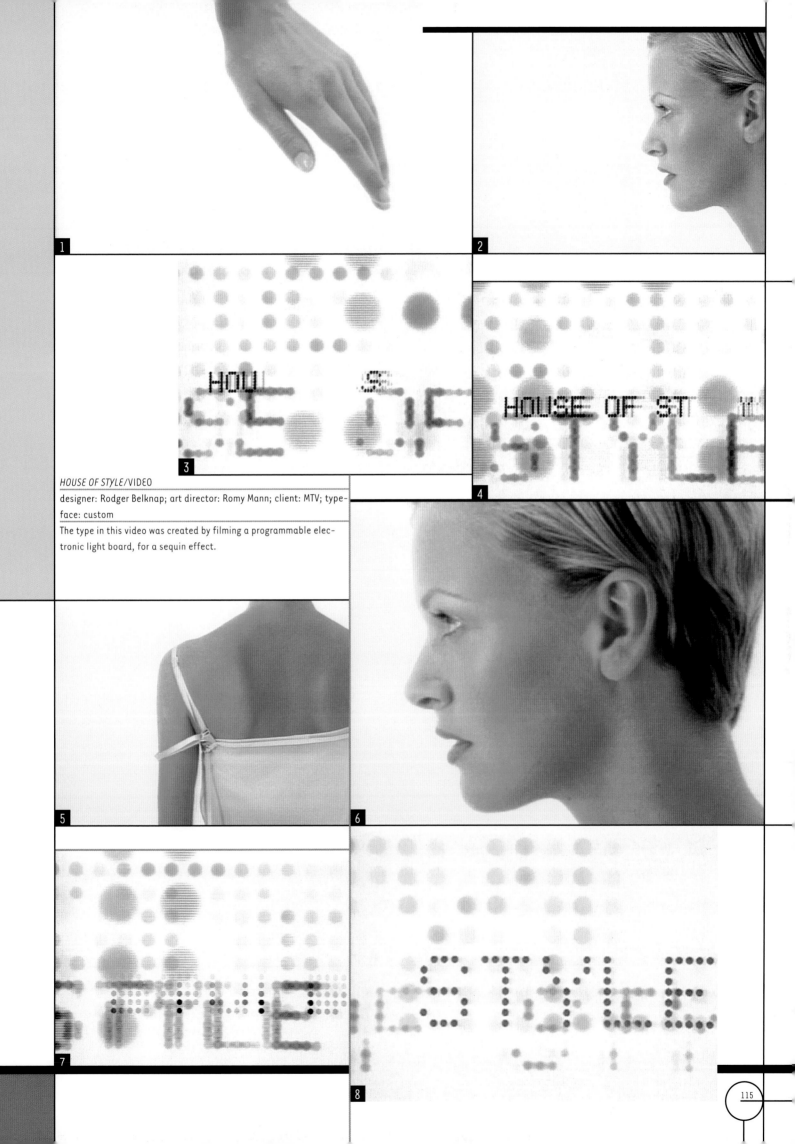

HOUSE OF STYLE/VIDEO

designer: Rodger Belknap; art director: Romy Mann; client: MTV; type-face: custom

The type in this video was created by filming a programmable electronic light board, for a sequin effect.

SPRING BREAK 1998/VIDEO
designer/director: Jenny
Rask; client: MTV; illustra-
tor/photographer: Jenny
Rask; typeface:
Spreakbring98
The type was inspired by *The
Rescuers*.

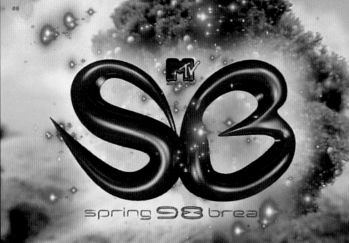

1

2

3

4

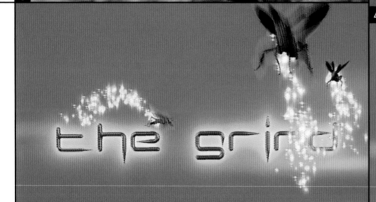

5

6

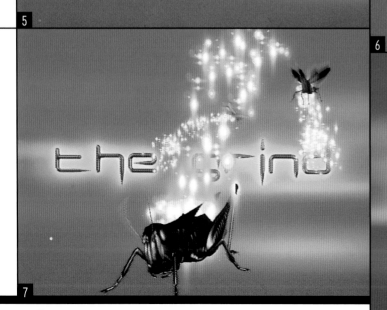

7

8

1

2

VIDEOS THAT DON'T SUCK/VIDEO
designer: Marisa Fazzina; art director:
Rodger Belknap; client: MTV; typeface:
Caslon Antique
Some of the characters were replaced by
flipped numbers and letters. "True
horror."

3

4

videos that

videos that don't suck

5

Len Peltier

Len Peltier studied advertising design and photography at Syracuse University and spent a year studying design and illustration in London. Peltier worked as art director for several major advertising agencies before being recruited by A&M Records, where as associate creative director he won a Grammy for Suzanne Vega's *Days of Open Hand*. Peltier has been vice-president and creative director at Virgin Records since 1992; he continues to design packages for Janet Jackson, Lenny Kravitz, and D'Angelo, and he also directs Vamp Films.

LENNY KRAVITZ, *CIRCUS*/CD COVER
art director: Len Peltier; designers: Steve Gerdes, Len Peltier; client: Virgin Records America, Inc.; photographer: Ruven Afanador; typefaces: custom (designed by Steve Gerdes)
The font of the title was inspired by circus poster type and movie posters.

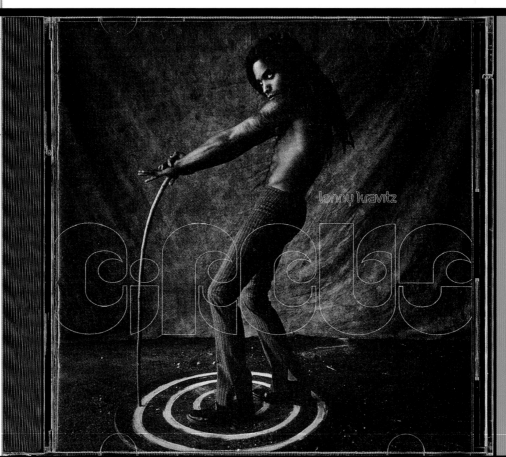

STING, *SOUL CAGES* SPECIAL PACKAGE/PACKAGING
designer/art director: Len Peltier; client: A&M Records; painter/illustrator: Steven Cambbell; typefaces: hand-lettered calligraphy
The type studies of Hermann Zapf inspired the typeface.

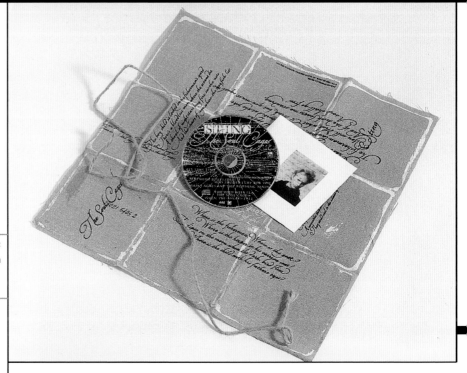

INTELLIGENT HOODLUM/CD
designer/art director: Len
Peltier; client: A&M
Records; photographer:
Bob Witkowski; typeface:
Helvetica
The type was reverse
printed on the transparent
plastic of the CD case.

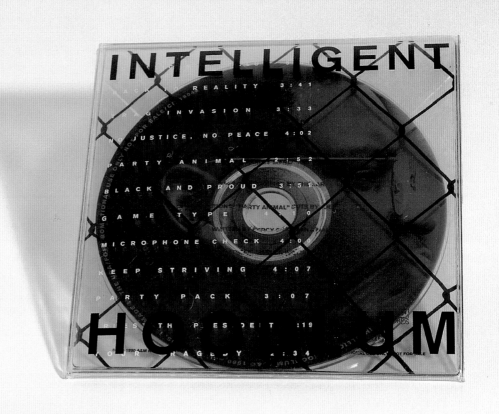

D'ANGELO, *DEVIL'S PIE/*
RECORD JACKET
designer/art director: Len Peltier;
client: Virgin Records America, Inc.;
typefaces: hand lettering, xero-
graphic manipulation
Multiple xerographic copies and
scans of the original lyric and credit
sheets were used for the record
cover.

Julian Peploe was born in 1969 in Winchester in southern England. He received his bachelor's degree of fine arts with honors from the School of Visual Arts and has worked his way up the ranks at Sony Music to design director for 550 music, whose roster includes Celine Dion, Ginuwine and Des'ree. He was nominated for a Grammy for *The Planet Sleeps*, a collection of lullabies from around the world.

Julian Peploe

GLOBAL BASICS/CD COVER
designer/art director: Julian Peploe; client: Columbia Records; typefaces: Bell Gothic, Handel Gothic
Peploe degraded the Handel Gothic with lines of varying thicknesses, inspired by the statement "Beam me up, Scotty" (from *Star Trek*).

FLAMMA FLAMMA/CD INSERT
designer/art director: Julian Peploe; client: Sony Classical;
photographer: Amy Guip; typefaces: Trajan, Trade Gothic

SONY CLASSICAL NEW MUSIC SAMPLER/CD COVERS
designer/art director: Julian Peploe; client: Sony Classical;
photographer/illustrator: Ali Campbell; typefaces: Trade
Gothic

DANCING DIVAS/CD INSERT
designer/art director: Julian Peploe; client: Epic Records; photographer:
Kenneth Willardt; typeface: Helvetica

SONY MUSIC STUDIOS/AD
designer/art director: Julian
Peploe; client: Sony Music
Studios; photography: stock;
photo-illustration: Julian
Peploe; typeface: News
Gothic

you want IT...

only when UR lonely
THE NEW SINGLE.

From his debut album,
GINUWINE...the bachelor ...

...1.5 million and still hittin'.
Produced by Timbaland for Timbaland Productions Inc.

www.ginuwine.com
www.550music.com
www.sony.com

Management:
Jomo Hankerson and B. Hankerson for Blackground Enterprises

GINUWINE. Repeatedly.

BK 67685
"550 Music" and design, "SONY," "Epic"
and ▨ Reg. U.S. Pat. & Tm. Off. Marca
Registrada./© 1997 Sony Music
Entertainment Inc.

GINUWINE/AD
designer/art director: Julian Peploe; client: 550 music;
photographer: Carl Lessard; typeface: Trade Gothic No.
18 Condensed

TYPO-LOGO STUDY

logos/illustration: James W. Moore, Lisa Nugent, Somi Kim, Beth Elliott; composition: Somi Kim; client: telecommunications company; typefaces: various

This was created from outtakes of an identity development for a technology client. The fonts used are adaptations of fonts, including Schadow and Antique Olive.

Somi Kim, Lisa Nugent and Susan Parr founded ReVerb in 1993, creating a new kind of agency to help companies reconnect with current culture and language, particularly youth culture. ReVerb's work ranges from identity overhauls to visual prototypes for brand expansion, using their combination of visual intelligence, language tuning and smart pragmatics.

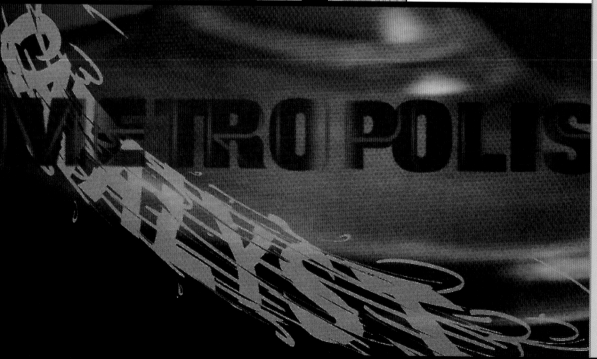

METROPOLIS, "CHAMPIONING THE VERB"/TITLE PAGE DETAIL

photography/art direction: Somi Kim, Lisa Nugent, Susan Parr, Whitney Lowe; client: Metropolis Magazine; typefaces: custom

This accompanied an article on ReVerb that focused on their image-development process. "Catalyst" was hand inked by Whitney Lowe, based on an original sketch by Lisa Nugent; "Metropolis" was created from Folio Extra Bold and Antique Olive Light Extended.

REVERB'S 1998 NEW YEAR'S CARD/POSTCARD
design: James W. Moore, Beth Elliott; client: self;
photographer: Lisa Nugent; illustrator: Somi Kim;
typefaces: dot matrix, Bureau Grotesque, unknown
woodtype ("ReVerb")

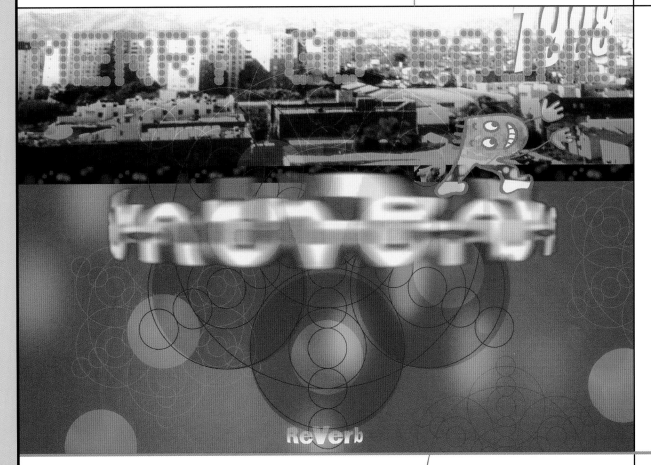

ReVerb@reverbstudio.com
5514 WILSHIRE BOULEVARD
SUITE 900 LOS ANGELES
CALIFORNIA 90036

THE REAL TECHNOLOGY— BEHIND ALL THE OTHER TECHNOLOGIES— IS LANGUAGE

```
/*
based on the January 1999 Wired
introduction.
project team: concept & design
by ReVerb, Los Angeles; java
code for thought bubbles
animation by Marius Watz/Amoeba,
Oslo; photo by Ed Nachtrieb,
Los Angeles
*/
```

www.reverbstudio.com/colophon
t 323-954-4370
f 323-938-7632

—NORMAN FISCHER, ABBOTT, GREEN GULCH FARM ZEN CENTER,
IN "THE WIRED DIARIES"

REVERB'S 1999 NEW YEAR'S CARD/POSTCARD
art direction: Somi Kim, Lisa Nugent, Susan Parr;
design: Somi Kim; client: self; photographer: Edward
Nachtrieb; typefaces: HTF Leviathan Black
Extended, Monospace, Kaatskill

REVERB ADDRESS STAMP/RUBBER STAMP

design: James W. Moore; client: self; typefaces: hand lettering ("ReVerb"), Monospace

This stamp was created to use on a poster given away after a ReVerb presentation at the THype conference sponsored by FontShop Benelux in Rotterdam in October 1998. The "ReVerb" type was hand drawn by James W. Moore.

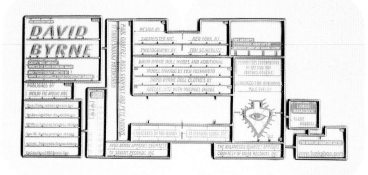

DAVID BYRNE, *FEELINGS*/CD INSERT

art directors: Stefan Sagmeister, David Byrne; designers: Stefan Sagmeister, Hjalti Karlsson; design studio: Sagmeister, Inc.; client: Luaka Bop, Warner Bros. Records; photographer: Tom Schierlitz; model maker: Yuji Yoshimoto; typefaces: custom, Franklin Gothic Regular, Franklin Gothic Bold

The type for the interior credits, which was inspired by type on a washing detergent package, was built as a model and then photographed.

Stefan Sagmeister, a native of Austria, received his master of fine arts in graphic design from the University of Applied Arts in Vienna and, as a Fulbright scholar, a master's degree from Pratt Institute in New York. Following stints at M & Co. in New York and as creative director at the Hong Kong office of the advertising agency Leo Burnett, Sagmeister formed the New York-based Sagmeister, Inc., in 1993. He designed graphics and packaging for the Rolling Stones, David Byrne, Lou Reed, Aerosmith and Pat Metheny. His work has received four Grammy nominations and has won many international design awards. Sagmeister lives in New York and loves Anni.

RYUICHI SAKAMOTO & YMO, *TECHODON/* CD PACKAGING

concept/design: Stefan Sagmeister; creative director: Tibor Kalman; computer mechanical: Eric Zim; design studio: Sagmeister, Inc.; client: Toshiba/EMI; photography: Ed Lachman (stock); agency: M & Co.; typefaces: Trade Gothic, Franklin Gothic, Bembo

This CD package includes ten different covers; it's up to the consumer to choose a favorite cover. Each cover contains coded typography—by American artist Jenny Holzer—which is only legible when the cover is put back inside the plastic jewel case.

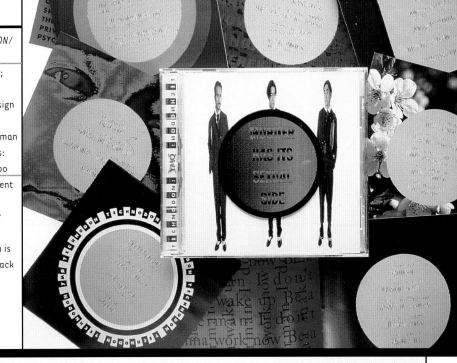

PAT METHENY, *IMAGINARY DAY/* CD PACKAGE

art director: Stefan Sagmeister; designers: Stefan Sagmeister, Hjalti Karlsson; design studio: Sagmeister, Inc.; client: Warner Bros. Jazz; illustrator: Tom Schierlitz; photography: stock; typeface: custom

The font was inspired by coding devices in the Science Museum (London); all type was replaced by symbols made up of commissioned and stock photographs. A diagram for decoding is printed on the CD.

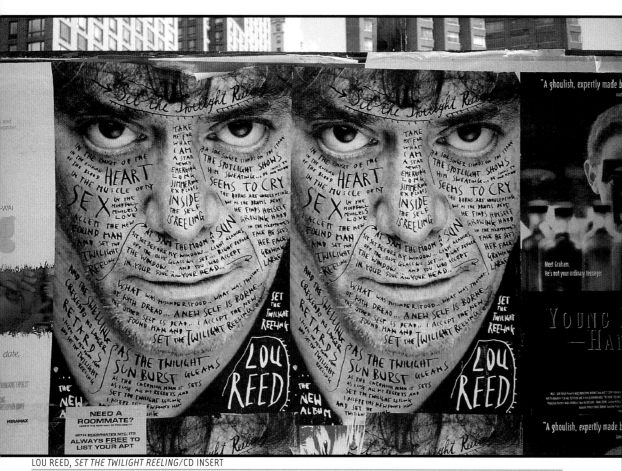

LOU REED, *SET THE TWILIGHT REELING*/CD INSERT

art director: Stefan Sagmeister; designers: Stefan Sagmeister, Veronica Oh; design studio: Sagmeister, Inc.; client: Warner Bros.
Music; photographer: Timothy Greenfield Sanders; typefaces: Bank Gothic, hand-lettered calligraphy

AFROPEA 3, *TELLING STORIES
TO THE SEA*/CD COVER
art director: Stefan
Sagmeister; designers:
Stefan Sagmeister, Veronica
Oh; design studio:
Sagmeister, Inc.; client:
Luaka Pop, Warner Bros.
Music; photographer: Tom
Schierlitz; typefaces: hand
lettering (title), Bembo,
News Gothic

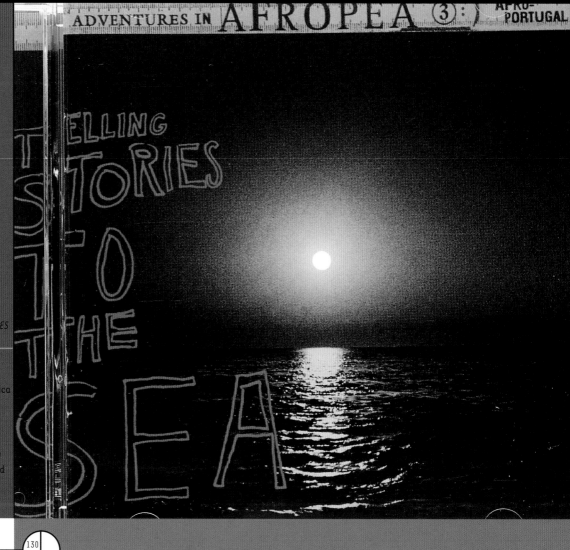

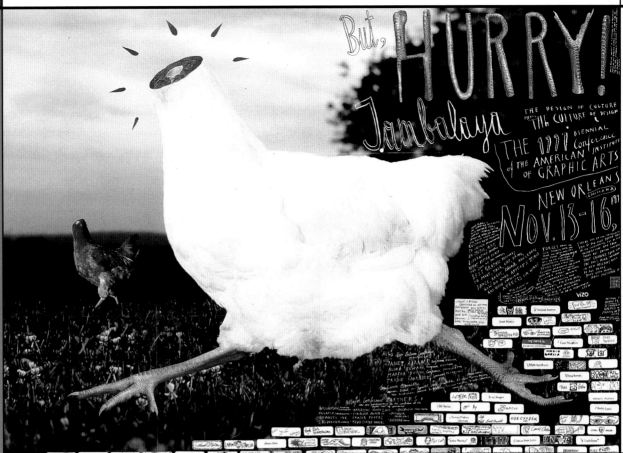

AIGA, "JAMBALAYA"/POSTER
designer/art director: Stefan
Sagmeister; design studio:
Sagmeister, Inc.; client: AIGA;
photographer: Bela Borsodi;
Paint Box: Dalton Portella;
illustration: Stefan Sagmeister,
Peggy Chuang, Kazumi
Matsumoto, Raphael Rüdisser;
typefaces: hand lettering
Adolf Wölfli, a turn-of-the-
century Swiss artist, was the
inspiration for the type.

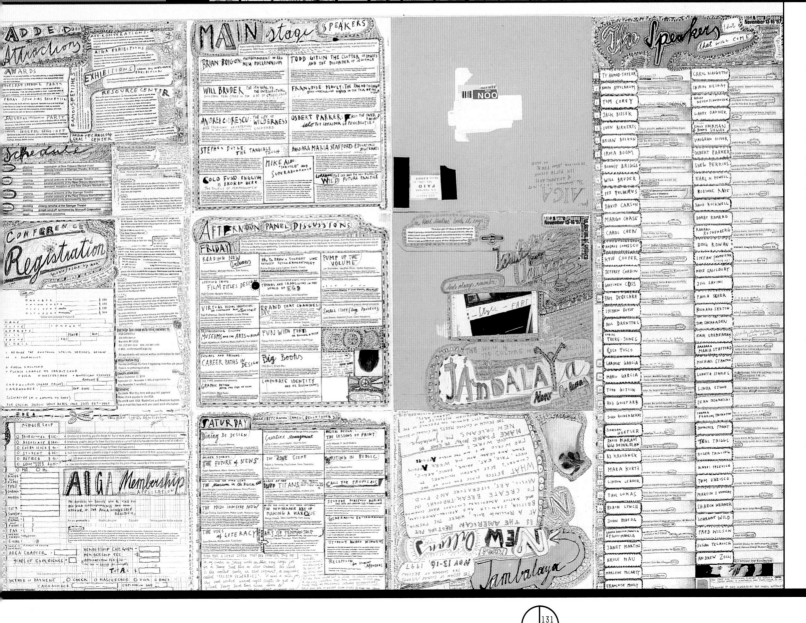

RICHARD BUCKNER, *SINCE*/CD PACKAGING
art director: Tim Stedman; designers: Tim Stedman,
Keith Tamashiro; client: Richard Buckner, MCA Records;
photographer: John Clark; typefaces: Franklin Gothic
Book, Franklin Gothic Demi
Richard Buckner envisioned a burning flame for *Since*;
Stedman realized this concept by cutting the type out
of balsa wood and scorching it.

Tim Stedman studied graphic design at the Art Institute of Houston and cinematography at UCLA. He founded Public Eye, a design firm targeting entertainment clients, including Paramount Pictures, Orion Pictures, Smart Egg Pictures, Virgin Records America, Warner Bros. Records, A&M Records and MCA Records. Currently he is vice-president and creative director for a major record company in Los Angeles, creating album packaging, marketing, merchandising and advertising design. A member of the faculty at both Otis College of Art and Design and Art Center College of Design, he teaches typography and effective self-marketing, respectively.

BLINK 182, *DUDE RANCH ADVANCE*/CD COVER
art director: Tim Stedman; designers: Tim Stedman,
Ashley Pigford; client: Blink 182, MCA Records; pho-
tographer: Steve Shea; illustrator: Lou Beach; type-
faces: Gill Sans (body copy and ancillary text),
Giddyup ("Dude Ranch"), custom (logo)
The primary type design was inspired by posters for
1930s B movies.

art director: Tim Stedman; designers: Tim Stedman, Keith Tamashiro; client: Snowpony, Radioactive Records; typefaces: Helvetica Compressed, Berthold Script, Bundesbahn Pi

1 bad sister **2** chocolate in the sun

they were doing t

snowpony are katharine gifford, debbie googe, produced by john mcentire. from the forthcoming visit the radioactive records promotional c

Ⓟ ©1998 Radioactive Records, J.V. Warning: All rights reserved

Tim Stedman, continued

RICHARD BUCKNER, *DEVOTION + DOUBT*/CD BOX

art director: Tim Stedman; designers: Todd Gallopo, Tim Stedman; client: Richard Buckner, MCA Records; photographer: Darcy Hemley; typefaces: hand lettering, text borrowed from "Creative Loafing"

CHARLIE SEXTON SEXTET, *UNDER THE WISHING TREE/*
CD SLEEVE

art director: Tim Stedman; designers: Tim Stedman,
Todd Gallopo; client: Charlie Sexton, MCA Records;
illustrator: Ivory Stanton; typeface: hand lettering
(by Todd Gallopo)

The type emulates pencil sketches on a paper bag,
suggesting the beginning of an idea.

STILL

STILL was established in 1999 by Chris Ashworth and Amanda Sissons, two of the three principals who art directed the music magazine *Blah Blah Blah* in 1996. Their work on the MTV Europe/Ray Gun Publishing joint project led them to design the book *Out of Control—Ray Gun Culture* (Booth-Clibborn Editions). Ashworth, who had art directed *Ray Gun Magazine*, and Sissons, who had also art directed *Ray Gun Magazine* and the launch of the club magazine *Sweater* with P. Scott Makela, collaborated with Michael Stipe on his book, *2xIntro—On the Road with Patti Smith* (Little, Brown).

BLAH BLAH BLAH/MAGAZINE
COVER (unpublished)
art director: Chris Ashworth;
designers: Chris Ashworth, Neil
Fletcher; client: Ray Gun
Publishing; photographers: Ian
and Peter Davies; typefaces:
Missive, Compacta, Futura, DIN

CREATIVE REVIEW, JANUARY
1995/MAGAZINE COVER
designers: Chris Ashworth, Dave
Smith; client: Creative Review; type-
face: Helvetica

RAY GUN STATIONERY
designer: Chris Ashworth; client: Ray
Gun Publishing; typeface: Helvetica

RAY GUN, "OUT OF CONTROL"/MAGAZINE SPREAD
art director: Chris Ashworth; designers: Chris Ashworth, Neil Fletcher; client: Booth-Clibborn Editions; photographer: John Holden; typefaces: various (Letraset)

SPECIAL FILM & MUSIC ISSUE. NO.48 AUGUST 1997

RAYGUN N®

WIM WENDERS & MICHAEL STIPE. DAVE GROHL & JANEANE GARDFA LD. JOHN WATERS & REDD KROSS. DAVID BYRNE & HAL HARTLEY. BIL LY BOB THORNTON. J MASCIS & AL LISON ANDERS. SLEATER-KINNEY. M KE MYERS' MING TEA. WILL OLDHAM STEVE BUSCEMI. BOND. BILL PAXTON. PLUS THE FAVORITE FILMS OF S HIRLEY MANSON. JAMES. LOU B ARLOW. SUEDE. ROBYN HITCHCO CK. BEN FOLDS FIVE. LUNA. ELA STICA. JOEY RAMONE. ERIC MAT THEWS. UNDERWORLD. & MORE...

$3.50 US $4.50 CAN

RAY GUN, NO. 48, "SPECIAL FILM & MUSIC ISSUE"/MAGAZINE COVER
designer/art director: Chris Ashworth; client: Ray Gun Publishing; photographer: Michael Stipe; typefaces: Alternate Gothic, Univers Condensed

RAY GUN, NO. 53, "GOLDIE"/MAGAZINE COVER
art directors: Chris Ashworth, Amanda Sissons; designer: Chris Ashworth; client: Ray Gun Publishing; photographer: Guy Aroch; typefaces: Univers Condensed, Microgramma, Helvetica, Gothic 725

RAY GUN, NO. 57, "GARBAGE"/MAGAZINE COVER
art directors: Chris Ashworth, Amanda Sissons; designer: Chris Ashworth;
client: Ray Gun Publishing; photographers: Ian + Peter Davies; typefaces:
Helvetica, Gothic 725

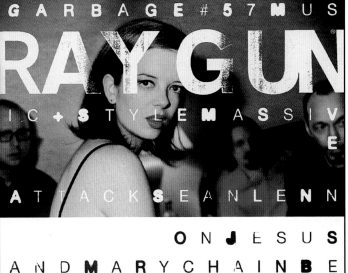

RAY GUN, NO. 54, "RADIOHEAD"/MAGAZINE COVER
art directors: Chris Ashworth, Amanda Sissons; designer:
Chris Ashworth; client: Ray Gun Publishing; photog-
rapher: Danny Clinch; typeface: Gothic 725

RAY GUN, NO. 57, "RETURN OF THE
WILD BUNCH"/MAGAZINE PAGE
art directors: Chris Ashworth,
Amanda Sissons; designer: Chris
Ashworth; client: Ray Gun
Publishing; photographer: Marc
Baptiste; typeface: Akzidenz
Grotesk

Studio 38

Studio 38, located in Berlin, Germany, is the full-service graphic design studio of Yannah Bandilla, Kathrin Janke and Reinhard Knobelspies. Studio 38 has done work for clients in the U.S., France and the Netherlands, as well as Germany; a satellite branch has been established in New York City. The principals' extensive interest and experience in photography, both still-life and fashion, led to their including a photography studio within the studio. Their client list includes Levi Strauss & Co., Elida Faberge Cosmetics, Jacobs Coffee Co. and Siemens.

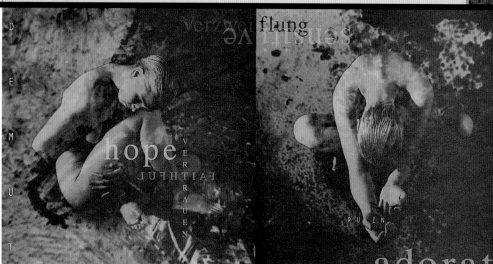

BODY AND EMOTIONS/BOOK
art directors: Yannah Bandilla, Kathrin Janke; designers: Yannah Bandilla, Kathrin Janke; client: Gmund Paper Co.; photographers: Yannah Bandilla, Kathrin Janke; typefaces: Times, Gill Condensed, Journal
This paper promotion for Gmund Paper Co. is also a companion book to the novel *Rebecca*, by Daphne du Maurier.

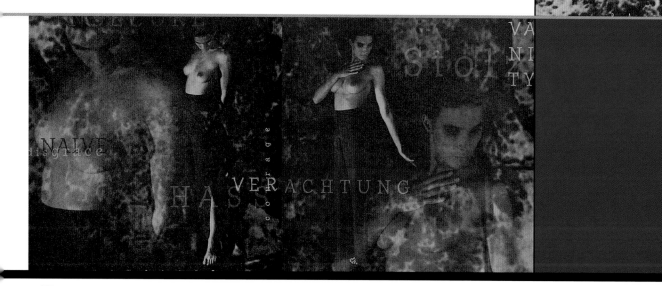

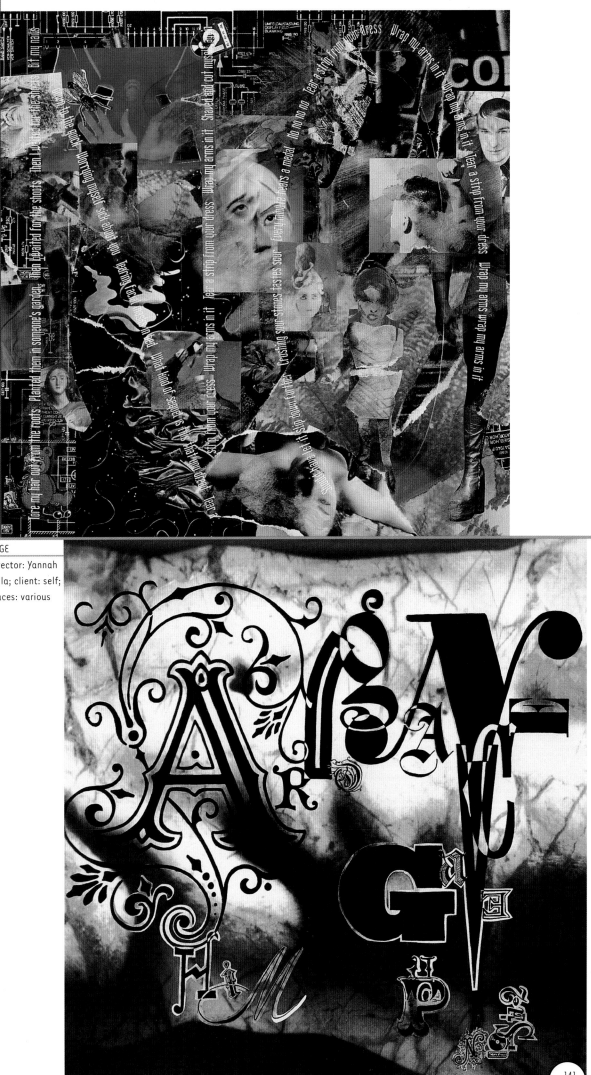

COLLAGE
art director: Yannah
Bandilla; client: self;
typefaces: various

verbindliche**tele**kooperation
das gleichgewichtsmodell für

management für **verteilte** anwendungen

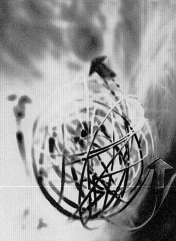

das ende der **sprach**losigkeit

JAHRESBERICHT 93 94

GMD/ANNUAL REPORT (1993-1994)

designer/art director: Reinhard Knobelspies;
client: GMD, National Research Center for
Information Technology; illustrator:
Reinhard Knobelspies; typefaces: Syntax,
Garamond Condensed

The logo was laser cut from acrylic and
photographed on an old piece of metal. The
negative was then scanned and color
corrected.

GMD/ANNUAL REPORT (1994–1995)
designer/art director: Reinhard
Knobelspies; client: GMD, National
Research Center for Information
Technology; illustrator: Reinhard
Knobelspies; typefaces: Syntax,
Garamond Condensed, various

A native New Yorker born in Little Italy, Turturro graduated from Pratt Institute in 1984. He worked at PolyGram Records before moving to Verve Records, a division of PolyGram Records that deals exclusively with jazz music. There he experienced what he feels was his greatest growth as a designer. Focusing on one genre of music and working with a small, close-knit group of team players, Turturro produced important pieces of design and received three Grammy nominations for best packaging in two years. Currently Turturro is working as a senior art director for the classical label at Sony Music, where he hopes to continue creating substantial pieces of work.

Giulio Turturro

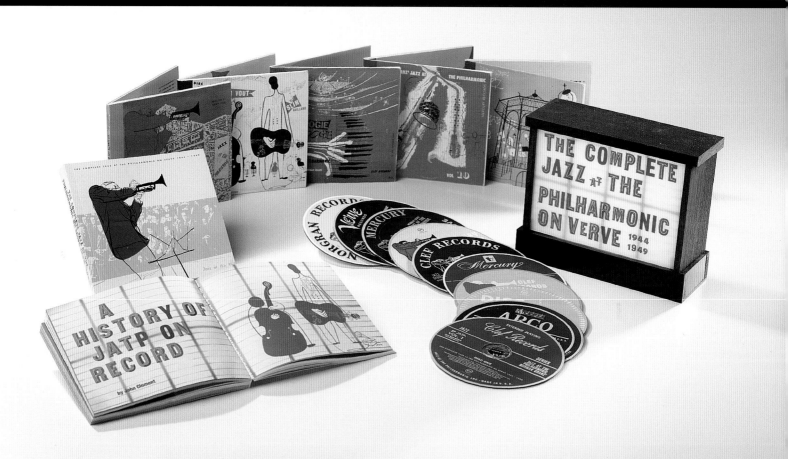

THE COMPLETE JAZZ AT THE PHILHAR-MONIC ON VERVE 1944–1949/
CD COLLECTION
designer/art director: Giulio Turturro;
client: Verve Records; photographer:
Phil Stern; typefaces: Cumicile family,
Franklin Gothic Heavy

COURTNEY PINE,
UNDERGROUND/
POSTER
designer/art
director: Giulio
Turturro; client:
Antilles;
photographer:
Kwaku Alston;
typefaces:
Platelet family
(Emigre)

COURTNEY PINE, *UNDERGROUND*/POSTER
designer/art director: Giulio Turturro; client: Antilles; photographer:
Kwaku Alston; typefaces: Platelet family (Emigre)

Produced by Philippe Saisse a[...]

Recorded by Eric Calvi & Christian Wie[...]

Mixed by Eric Calvi

1 Me & The Boyz 4:31 2 Masques
4:57 3 Madison Rose 5:14
4 Feelin' Kinda Sexy 4:36
5 Proko-Groove 6:47 6 Secret
Garden 1:10 7 Wolverine 5:26
8 Maurice & Igor 5:42 9 Prelude
6:15 10 Images 6:10 11 Will You
Ever Know 2:46

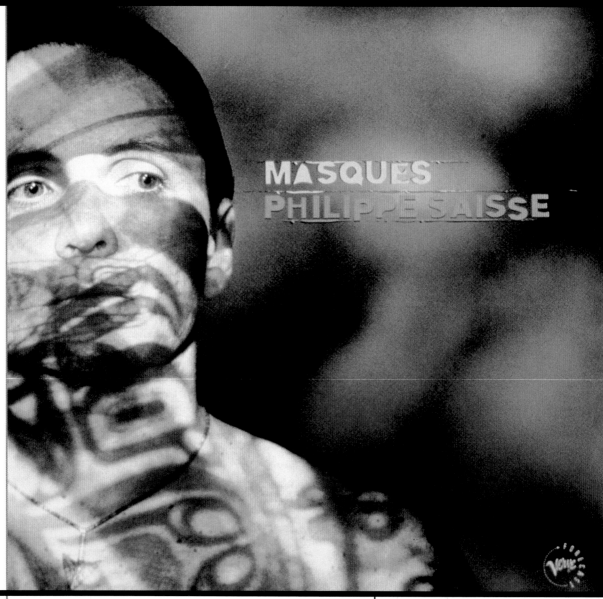

PHILIPPE SAISSE, *MASQUES*/CD COVER
designer/art director: Giulio Turturro;
client: Verve Records; photographer:
Mark Higashino; typeface: Autotrace

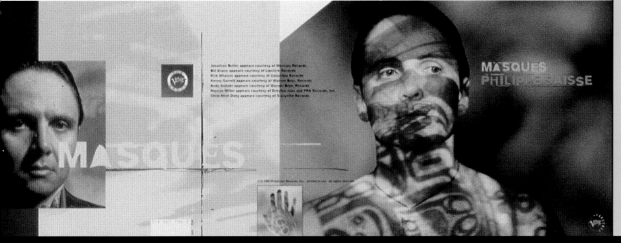

PHILIPPE SAISSE, *MASQUES*/CD INSERT
designer/art director: Giulio Turturro;
client: Verve Records; photographer:
Mark Higashino; typeface: Autotrace

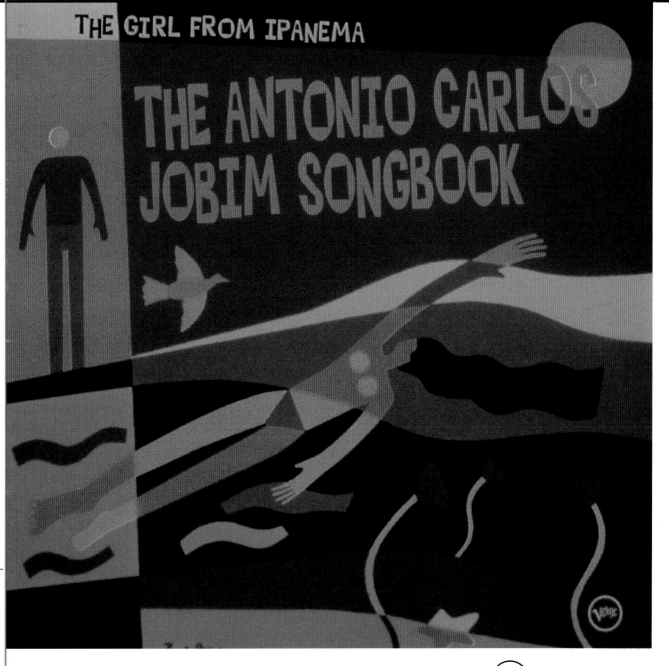

*WAVE: THE ANTONIO CARLOS
JOBIM SONGBOOK*/CD COVER
designer/art director: Giulio
Turturro; client: Verve
Records; illustrator: Zita
Asbaghi; typeface:
Beachouse

In 1996 two:Design was founded by David Coventon and Graham Peake in a Camden pub over a couple of pints. Graduates of the Master of Arts Graphic Design course at Central Saint Martins, London, they established the partnership and studio when both became disaffected with the creative directors for whom they worked, who seemed to have lost the "plot," creatively speaking, that is. In a little under two years they have kicked out a large body of work for several music industry clients, including a monthly magazine, *The Bomb*. With a growing team of associates they are expanding their portfolio to encompass Web site design, diverse street level fashion, marketing and advertising campaigns and, yes, even a few corporate jobs.

WYCLEF JEAN, "WE TRYING TO STAY ALIVE"/POSTER
art director: Graham Peake; designers: Graham Peake, David Coventon; design studio: two:Design; client: Columbia Records/Sony Music Entertainment (UK) Ltd.; typefaces: Buttnut, Buttnut Outline, Mr. Frisky ("The Carnival," designed by Chank)
Buttnut was created by converting and tweaking a free font from the Internet.

WYCLEF JEAN
FEATURING REFUGEE ALLSTARS
THE SINGLE
WE TRYING TO STAY ALIVE
OUT JUNE 16
THE MASTERMIND BEHIND THE
Fugees
RETURNS WITH
THE ALBUM
THE CARNIVAL
OUT JUNE 23

DOWNLOW MAGAZINE, "BEATS FROM THE BRICKS"/MAGAZINE SPREAD

designer/art director: Graham Peake; design studio: two:Design; client: Downlow Productions; typefaces: Moore, Leonardo Da Vinci (song lyrics)

The type is reminiscent of street graffiti.

DOWNLOW MAGAZINE, "WU-TANG COMES FULL CIRCLE"/MAGAZINE SPREAD

designer/art director: Graham Peake; design studio: two:Design; client: Downlow Productions; photographer: Phil Knott; typefaces: Snderfistad (headline), Laderbg (subheads), Utility Bold Condensed (body copy)

Using the graffiti and tagging seen around London as inspiration, Peake digitally manipulated the fonts to create an appropriate setting for Wu-Tang, a hip-hop artist.

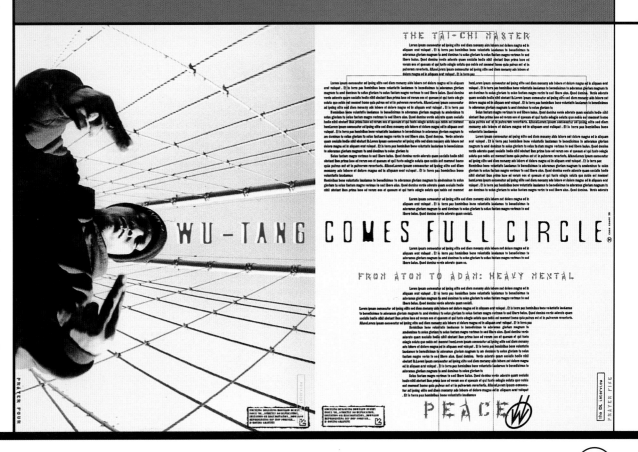

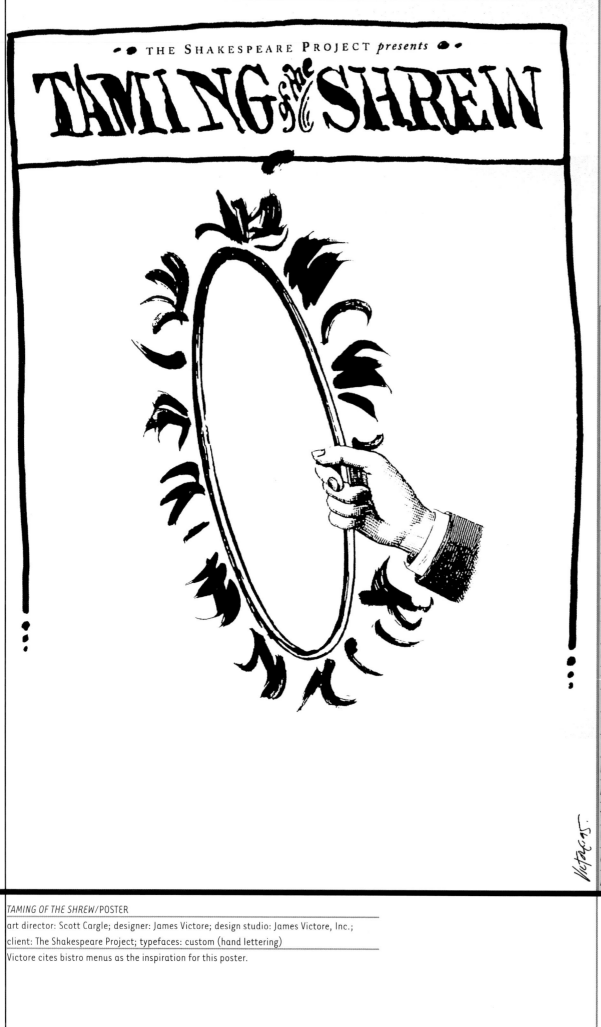

James Victore is a self-taught, independent designer who produces posters, books, brochures, illustrations, animation and a bit of advertising. A good day for Victore includes a big lunch and a nap. Victore's posters are in the permanent collections of the Library of Congress; the Museum für Gestaltung, Zürich; and the Palais du Louvre, Paris; to mention a few. He has won numerous national and international awards including an Emmy and the Grand Prix from the International Design Biennale in the Czech Republic. His clients include the School of Visual Arts, Portfolio Center, *Wired Magazine*, Showtime, *The New York Times*, the NAACP and the Anti-Defamation League. He currently teaches graphic design at the School of Visual Arts in New York City.

TAMING OF THE SHREW/POSTER

art director: Scott Cargle; designer: James Victore; design studio: James Victore, Inc.;
client: The Shakespeare Project; typefaces: custom (hand lettering)
Victore cites bistro menus as the inspiration for this poster.

PORTFOLIO CENTER/AD
designer/art director: James Victore; design studio:
James Victore, Inc.; client: Portfolio Center; type-
faces: custom (hand lettering)

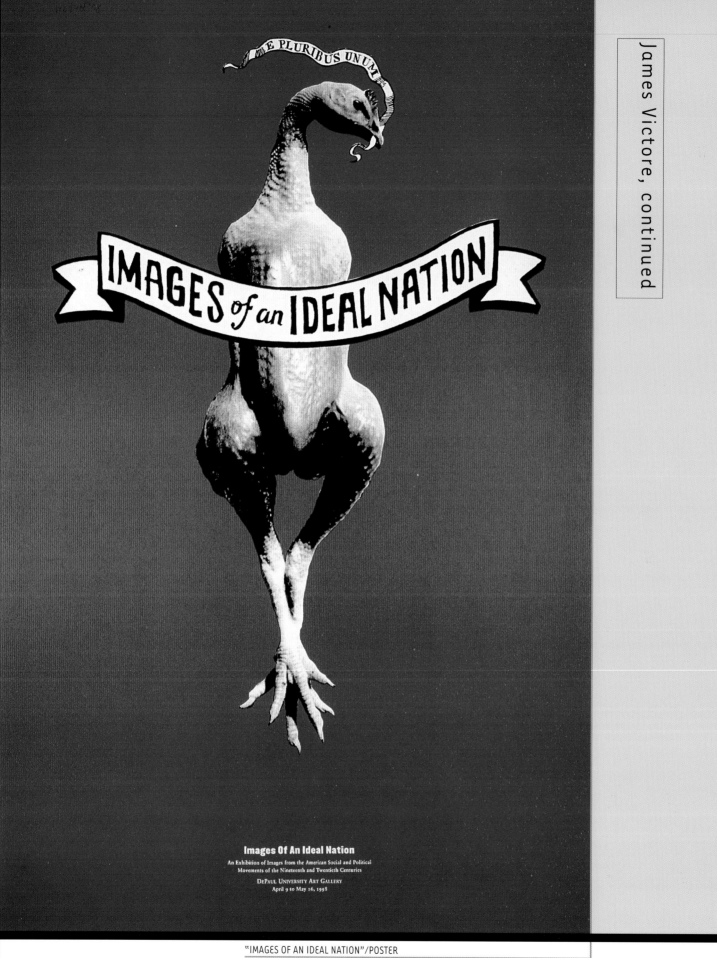

"IMAGES OF AN IDEAL NATION"/POSTER

designer/art director: James Victore; design studio: James Victore Inc.; client:
DePaul University; photographer: James Victore; typefaces: custom (hand lettering),
Akzidenz Grotesk

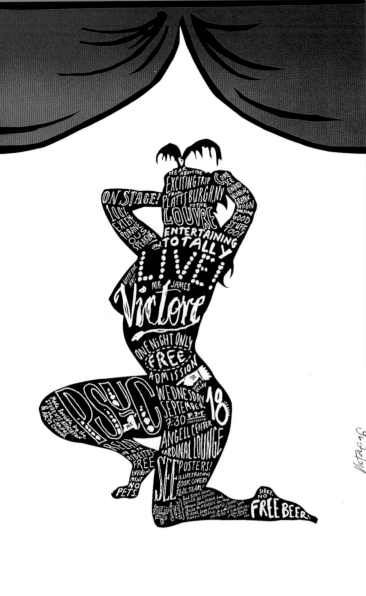

Barbara de Wilde is a graphic designer functioning primarily in the world of book jacket design and music packaging. Her work for Alfred A. Knopf and other publishers—including Farrar Straus & Giroux; W.W. Norton; Little, Brown; and Random House—has been featured in *Eye*, *Print*, *Graphis*, *Vanity Fair*, *Time* and *I.D.* magazines. The latter chose her as part of its first "I.D. Forty" group of the nation's top designers. Her work has been included in various exhibits by the AIGA; American Center for Design; Art Directors' Club; and Cooper-Hewitt, National Design Museum (Smithsonian Institution). She currently teaches graphic design at the School of Visual Arts in New York City and is a regular contributor of visual commentary to the *New York Times* Op-Ed page.

Barbara de Wilde

DELIRIUM/BOOK JACKET
art director: David Cohen; designer: Barbara de Wilde; client: Hyperium; photographer: Joyce Tenneson; typefaces: Heliotype ("Delirium"), Bell Gothic

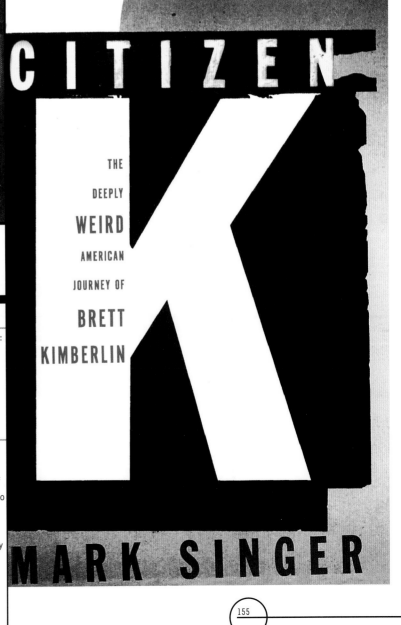

FRAGMENTS

Fragments

MEMORIES OF A CHILDHOOD
1939-1948

Binjamin Wilkomirski

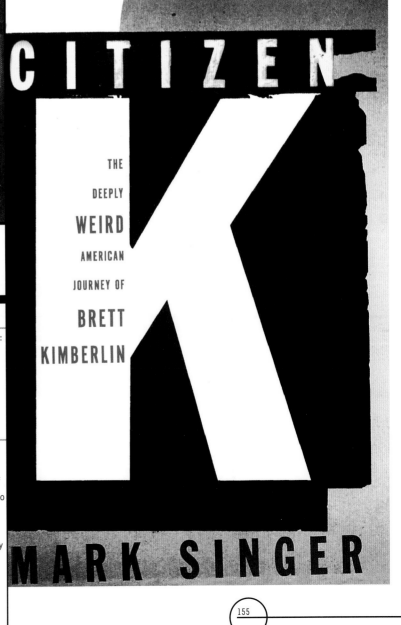

CITIZEN

K

THE
DEEPLY
WEIRD
AMERICAN
JOURNEY OF
BRETT
KIMBERLIN

MARK SINGER

FRAGMENTS/BOOK JACKET

art director: Marge Anderson; designer: Barbara de Wilde; client: Pantheon Books; illustrator: Barbara de Wilde; typefaces: Fournier (large type, title, subtitle), Bell Gothic (author)

CITIZEN K/BOOK JACKET

art director: Carol Carson; designer: Barbara de Wilde; client: Alfred A. Knopf; typefaces: Franklin Gothic Bold (title), various condensed gothics combined with Franklin Gothic Condensed and Alternate Gothic

The large letterforms and "Citizen" were enlarged photocopies that were made into rub-on transfers of colored foil; these were rubbed onto a surface that was not very adhesive, causing the lettering to flake off. The result was photographed by de Wilde and the smaller type was applied to the photograph.

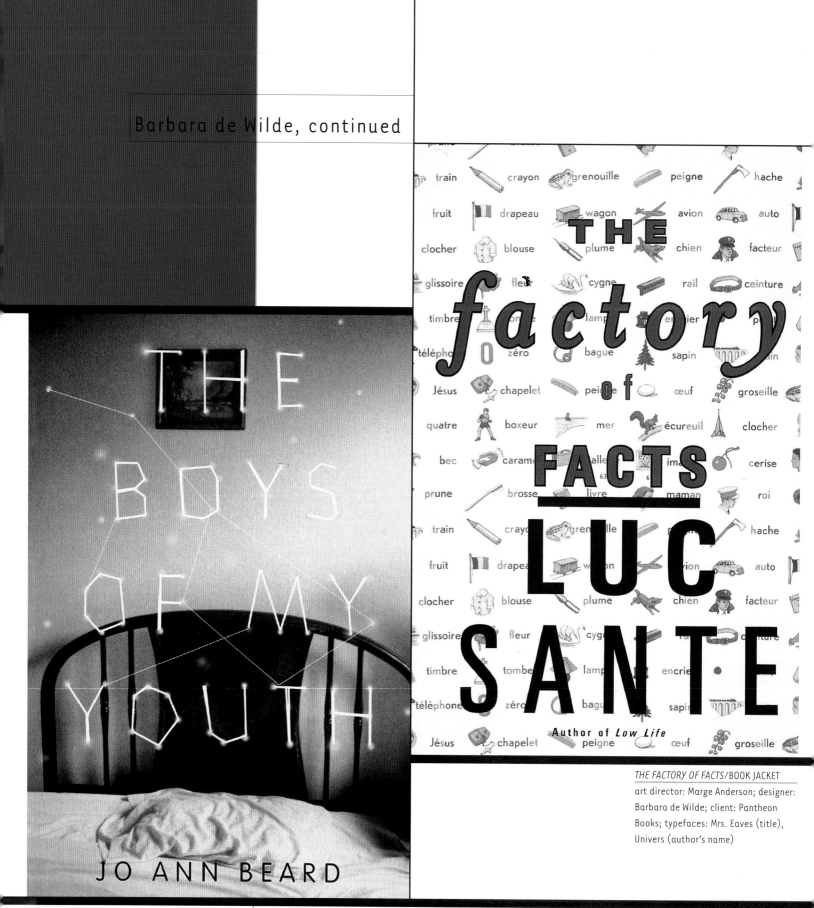

THE FACTORY OF FACTS/BOOK JACKET
art director: Marge Anderson; designer:
Barbara de Wilde; client: Pantheon
Books; typefaces: Mrs. Eaves (title),
Univers (author's name)

THE BOYS OF MY YOUTH/BOOK JACKET

art director: Michael Ian Kaye; designer: Barbara de
Wilde; client: Little, Brown; photographer: Michael
Wilson; typefaces: hand lettering (title), VAG Rounded
The type, dots ("constellations"), and hairline rules
were placed as separate layers in Adobe Photoshop.
The topmost layer consisted of tracings of the original
typeset letterforms on the bottommost layer, which
was discarded.

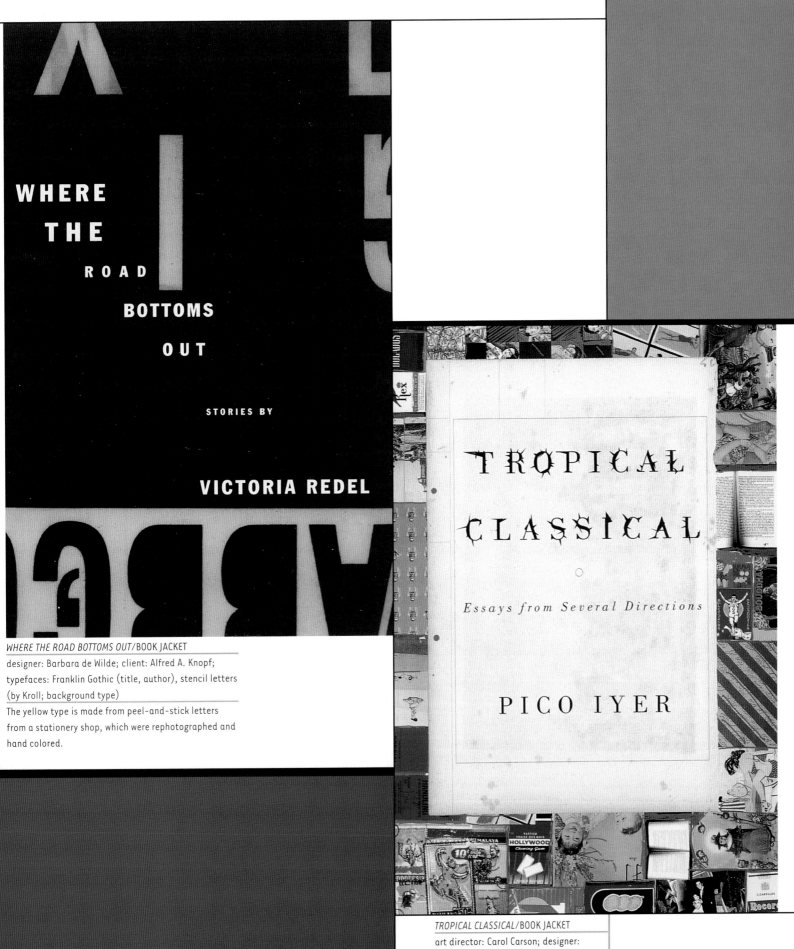

WHERE THE ROAD BOTTOMS OUT/BOOK JACKET
designer: Barbara de Wilde; client: Alfred A. Knopf;
typefaces: Franklin Gothic (title, author), stencil letters
(by Kroll; background type)
The yellow type is made from peel-and-stick letters
from a stationery shop, which were rephotographed and
hand colored.

*TROPICAL CLASSICAL/*BOOK JACKET
art director: Carol Carson; designer:
Barbara de Wilde; client: Alfred A. Knopf;
illustrator: Barbara de Wilde; typefaces:
hand-drawn Bodoni

BACKWARD
FUTURE: DEVOLUTION VS. REINVENTION

stripped our capacity to produce them. What can be the next big thing when it is rendered instantly disposable through recognition?

Never before have we seen so many tributes to new design with such a lack of deep conceptual analysis. Never before have advertising agencies and corporations pursued with such vigor the street level trend, instantly feeding it back to a culture seemingly unable to resist. Any counterculture or style managing to manifest itself can't hold out more than a few seconds before racing into an ardent embrace by the

Not since Guttenberg invented movable type in the fifteenth century has such a broad dissemination of technology occurred. Prior to the printing press, the power of the written word was held by only a handful of scribes. With this new tool, however, anyone able to activate the technology could themselves disperse information, causing an uproar among the elite who had previously controlled the distribution of knowledge. Six hundred years later, electronic communication presents a similar environment.

In one enormous technological leap,

This has led to a dramatic increase in the number of voices competing for recognition. Anything is possible for anyone who can access or afford the technology. Aesthetically, one doesn't need a special design certificate in order to create and distribute your vision globally. In fact, many of the best events in design today have been initiated by those who have not been formally "trained." The downside is that the advance of similar applications and platforms across the field has created a certain style glut: everything from the return of the modernist grid (à la QuarkXPress) to such faux pas as

mainstream, and on to lucrative careers as stylistic devices in commercials, where the real money goes down.

Meanwhile our culture at large has experienced a devolution of language–where complex and precise words are discarded for the handy fashionable phrase, and complex ideas are reduced in conversation to mere fodder for repartee. History grounds us, delineating reference points on the map of human conciousness. Know your history. Nothing is new. It is up to each of us to reinvent the magic of

the defensive industry and Alexander Bell's century-old invention have come together to create an entity known as cyberspace. Our cultural landscape, not to mention the structure of mass-mediated forms of expression, have been forever changed. As recently as two decades ago our lives in relation to media were much different–our pursuits were defined by the mass media. Today we have the potential to become the mass media. There is now a place where billions of voices define themselves, concurrently, personalizing and transforming the way in which we communicate.

stretched type and unreadable point sizes, Carsoncopies and the font-of-the-minute club–all result in the dilution of the new and the proliferation of sameness.

While increasing communication and discourse, the rapid transfer of ideas across the planet has also created a certain chilling effect. Message and medium are defined with equal importance in the information age. Ease of appropriation (ideas, images, sounds, styles) fosters a climate where everyone is in search of the next big thing. It is almost as if our appetite for new ideas has out-

perception.

By **Joshua Berger**
Plazm

Layout: Chris Ashworth – Still
Image: John Holden

Credits